IRELAND'S
COAST

CARSTEN KRIEGER

THE O'BRIEN PRESS
DUBLIN

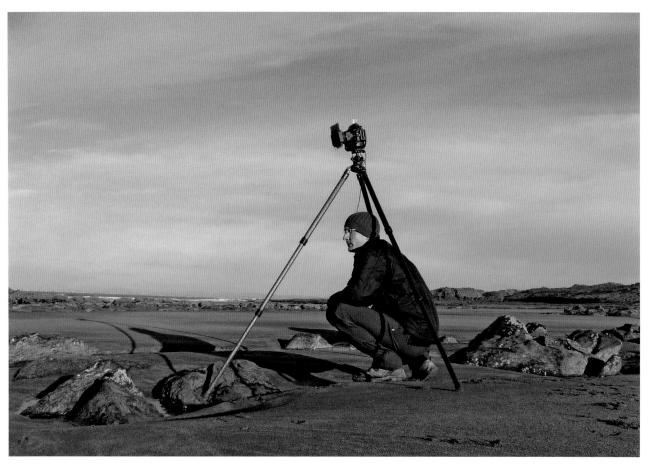

CARSTEN KRIEGER is a professional photographer based in the west of Ireland. His unique images are highly acclaimed and over the past decade he has become one of Ireland's foremost photographers, covering subjects from landscape and nature to architecture and food photography.

He has published and contributed to numerous books on Ireland's landscape, wildlife and heritage, including the bestselling *Ireland's Wild Atlantic Way*, and regularly works for Failte Ireland, The UNESCO Burren and Cliffs of Moher Geopark and other clients.

CONTENTS

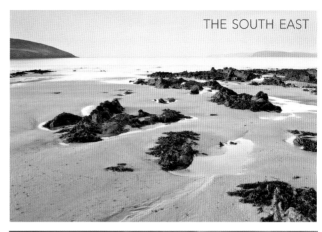

THE SOUTH EAST

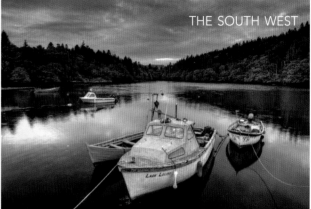

THE SOUTH WEST

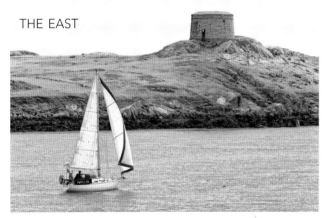

THE EAST

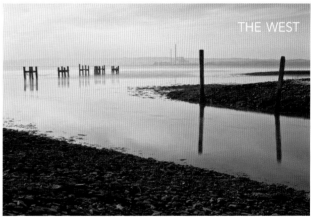

THE WEST

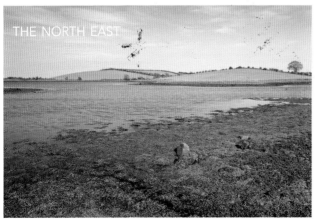

THE NORTH EAST

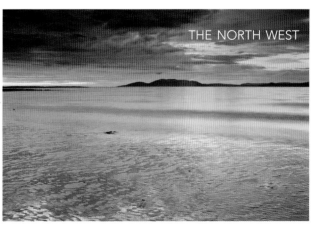

THE NORTH WEST

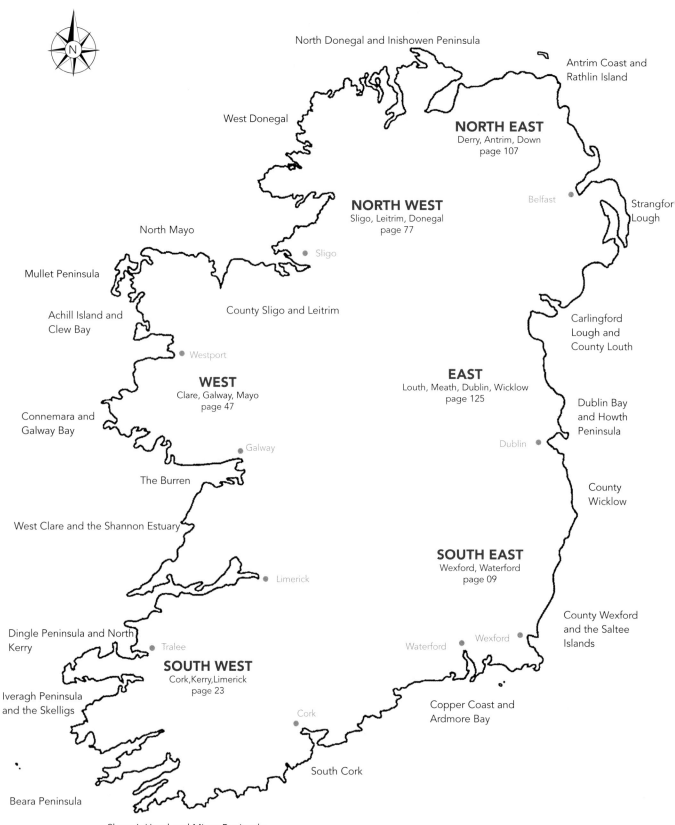

North Donegal and Inishowen Peninsula

Antrim Coast and Rathlin Island

West Donegal

NORTH EAST
Derry, Antrim, Down
page 107

Belfast

Strangfor Lough

North Mayo

NORTH WEST
Sligo, Leitrim, Donegal
page 77

Mullet Peninsula

Sligo

Achill Island and Clew Bay

County Sligo and Leitrim

Carlingford Lough and County Louth

Westport

WEST
Clare, Galway, Mayo
page 47

EAST
Louth, Meath, Dublin, Wicklow
page 125

Dublin Bay and Howth Peninsula

Connemara and Galway Bay

Galway

Dublin

The Burren

County Wicklow

West Clare and the Shannon Estuary

Limerick

SOUTH EAST
Wexford, Waterford
page 09

County Wexford and the Saltee Islands

Dingle Peninsula and North Kerry

Tralee

Wexford

SOUTH WEST
Cork, Kerry, Limerick
page 23

Waterford

Iveragh Peninsula and the Skelligs

Copper Coast and Ardmore Bay

Cork

South Cork

Beara Peninsula

Sheep's Head and Mizen Peninsula

FOREWORD

Half-a-billion years ago Ireland was otherwise and elsewhere. The sub-equatorial supercontinent that contained Ireland was washed by a great sea, the shore of which can still be detected, not around, but through the middle of Ireland. Since then the drag and pull of continental drift and tectonics has shifted and sundered our little landmass.

Repeated glacial grooming and bathing in fluctuating seas have rendered it the familiar 'shaggy dog-on-its-side' of today.

The seas continue their influential work – aggressively so on the Atlantic coast, more benignly to the east. Our coast is also soothed by the warm Gulf Stream and nourished by the cold upwellings in the Celtic sea.

The amazing scenic variety that typifies our coastline may be viewed as a grand collusion of art and science: of relentless elemental sculpting on obdurate geology. This work in progress has multiple expressions in the headlands and islands, inlets and estuaries, dunes and beaches ... that define our country's margin.

The twice-daily tidal rhythm of exposure and concealment imposes a lifestyle of tolerance on the flora and fauna. The zonation of intertidal seaweeds and winkles reflects this. In the hidden world of deeper water, molluscs, crustaceans and fish respond to other ecological imperatives. At the top of the food chain sea birds and marine mammals exploit this fecundity.

In summer our coasts become nurseries for mind-boggling assemblages of fulmars, kittiwakes, guillemots and razorbills, jostling for footholds on cliffs and rocky islets. These seabird cities are among the greatest nature spectacles in Europe.

The first people to come to our shores were drawn to river outfalls where shellfish could be gathered and migrating fish hunted. The arrival of agriculture did little to deter fisherfolk from occupying the coast, building permanent settlements and constructing boats fit for purpose. Trading added a further consolidating dimension leading to the development of ports. Such coastal foci have, down the ages, acted as conduits of cultural infusion.

Today coastal utility is in transition. Solid traditional industries, fishing and shipbuilding, have been overtaken by more speculative enterprises like fish-farming. Increasing energy demand proposes offshore windfarms and less intrusive wave-harnessing. Much recreational activity is also now associated with our shores. Eco tourism has become a significant consideration in the revitalisation of our coastal communities: we are nevertheless only beginning to evaluate and appreciate our birds and whales and breath-taking coastal scenery.

Carsten Krieger's marvellous photographs remind us of what we still have and warn us about what we have to lose.

Gordon D'Arcy

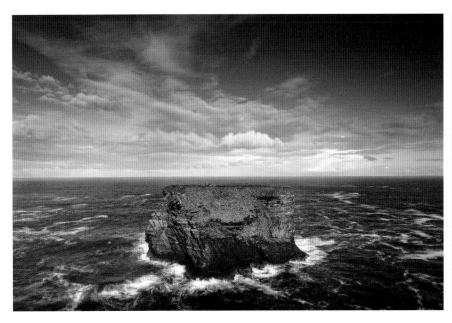

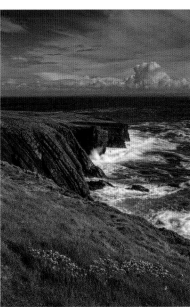

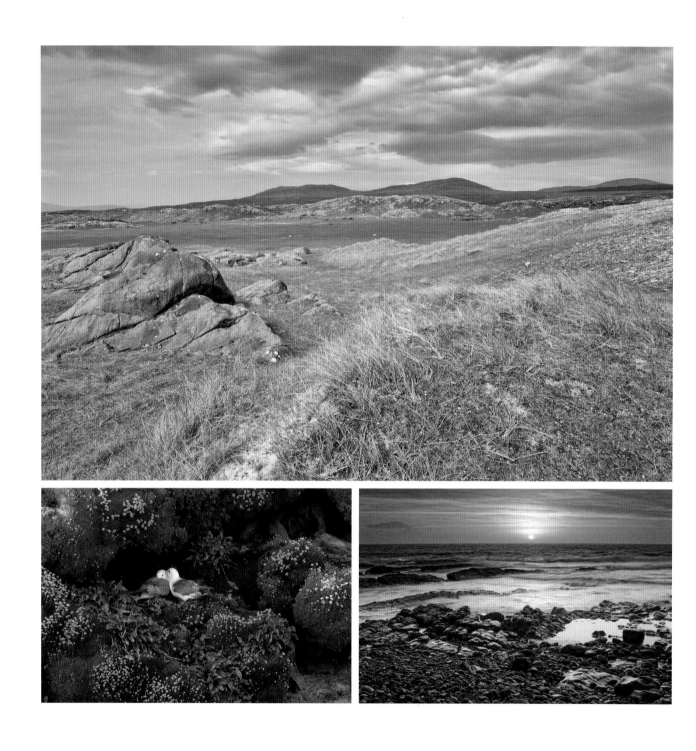

Top: Machair, Silver Strand, County Mayo. Bottom left: Fulmars, Loop Head, County Clare.
Bottom right: Winter Solstice sunset, Kilbaha Bay, County Clare

INTRODUCTION

My first memory of Ireland's coast are the smooth pebbles at Ross Behy Strand at high tide, the incoming surf and that unique clacking sound that comes with each retreating wave. This was the first time I laid eyes on the Atlantic Ocean and it was probably the time my love affair with the coast began.

The coast, the magical border between land and sea, the dividing line between earth and water, calls out to all of us. It's a place of constant change that seems to hold the memories of our own ancestral beginnings.

Ireland, this small island at the edge of Europe, calls some 7,500 kilometres of shoreline its own. Ireland's coast as we know it today is a product of the latest glaciation during the ice age. Around twenty thousand years ago most of Northern Europe, including Ireland, was covered by a huge ice sheet. The sea level was some 120 metres lower than today, and Ireland and Britain were joined together and had a connection to the European mainland.

When temperatures started to rise about fifteen million years ago the glaciers eventually started to melt and water levels began to rise. It was then that the retreating ice carved the landscape, leaving behind the sea loughs of Ireland's northern coast, the great peninsulas of the southwest and many other features of today's coast like the drumlin islands of Clew Bay.

The rising temperatures also allowed plants to get a foothold and they were soon followed by animals that crossed the quickly disappearing land bridge between Britain and Ireland. Following the animals were the first humans who arrived in Ireland around ten thousand years ago. It is thought that these hunters and gatherers arrived in Northern Ireland by boat from Scotland, other groups probably managed to cross the land bridge from southern Britain into southern Ireland before it got swallowed by the Irish Sea.

At this time Ireland was covered by an almost impenetrable boreal forest and the first settlers stayed mainly along the coast and river estuaries. Evidence for their presence can still be found today in forms of heaps of shells above the high tide line. Imagine a group of people on a sheltered part of a beach, sitting around a fire, roasting and cooking their cockles, razor clams and mussels. When the meal is finished they just toss the empty shells behind them. Over time these midden heaps reached considerable height and today allow archeologists a unique insight in the diet of our ancestors. Today these heaps are covered by sand and grown over by dunes and other vegetation, but from time to time wind and tides uncover pockets of shells, often at the base of shifting dunes, and allow even us non-archaeologists a glimpse in to the past.

Over the following centuries Ireland and its coast changed dramatically. The climate became warmer and more humid and sea levels rose further. The hunter-gatherers settled down, became farmers and started to cut down trees to make space for fields. The combination of climate change and human interference meant the end of the forests and the rise of the bogs. Evidence of this process can still be found today and some of the most impressive examples are located at the coast. Rinevella Bay at the Shannon Estuary holds an example of what is known as a drowned or petrified forest; the middle and lower shore of this bay is made of peat with countless tree trunks still embedded in it. Once a dense forest must have covered what is now the estuary of Ireland's longest river, deer and boar must have roamed where today seals and dolphins are swimming. Places like this are mind boggling and encourage us to look into our distant past.

Today Ireland's coast is a jigsaw of many different habitats: sandy beaches, including adjoining dune systems and the unique 'machair' – a sandy grassland that can only be found in the North West of Ireland and the west of Scotland – make up more than two thousand kilometers of the Irish coast; river estuaries provide shelter for salt marshes and vast mudflat areas; there are also rocky shores are made of rock platforms, pebbles, stones or boulders, soft cliffs made of stones and dirt and hard cliffs that rise to a height of several hundred metres.

Although people over time ventured and settled inland the coast remained a vital and constant influence on the Irish people. Dune grasses provided the raw material to thatch houses, seaweed became a common fertilizer, but first and foremost the sea and coast have always been a source of food. In more recent times, seafood has grown into an important industry.

Being a fishermen on an island sounds like the perfect job. Unfortunately cheap fish imports from overseas, over fishing and resulting regulations and quotas make life anything but easy for Irish fishermen, especially for the smaller local enterprises. But there are still many thriving ports around Ireland like Howth, Dingle or Killybegs whose fishermen not only supply for the domestic market but also export their goods around the world.

For many people, however, the coast means one thing: holidays! The Irish coast is probably the most important asset for the tourism

industry and is marketed to suit both the active and not so active visitor. Water sports like sailing, surfing and kayaking have become very popular. More recently the tourism industry has also discovered the coastal wildlife and eco tour operators are now offering dolphin, whale, seal and other wildlife watching trips.

This however puts the coast and its inhabitants under constantly-growing pressure. Littering, pollution, over-fishing and destruction of habitat are just a few factors that threaten Ireland's coast.

Making this book was a journey of discovery in many different ways. First there was the actual journey around the fringes of Ireland by car, boat or on foot. At times, this journey seemed to go on forever, on narrow country roads around long stretched peninsulas, along the shores of sea loughs and over choppy seas to some mystical island.

It was also a very personal journey. In the early stages my goal was to capture the wild and varied landscape of the Irish coast. But soon it became clear that the Irish coast has more to offer and I went back to my roots as a wildlife photographer trying to capture the coastal fauna from the nervous hermit crab to the mighty fin whale.

Although we like to think of the coast as a wild place, it has been very much shaped by human hands. It's impossible to travel along the coast without seeing piers, harbours, lighthouses and watchtowers; most of the time this built landscape is rather picturesque and forms an integral part of Ireland's coast. It's only another small step from

photographing coastal architecture to photographing its creators, carving a living out of the coast's resources or simply enjoying it.

The wild coast, the built coast and all its inhabitant are all part of a tightly-woven net and once I embraced the idea of capturing all aspects of Ireland's coast I found myself in, for me, rather unusual circumstances. I visited a sail maker on the Mizen Peninsula, followed the building of a traditional sailing boat in West Clare and photographed the surfing championships in Bundoran. I spent many hours onboard a boat on the Shannon Estuary trying to get the perfect dolphin shot, I was photographing fishmongers in Howth and lost myself in the eerie intestines of Hook Lighthouse. But taking this plunge into the unknown not only made me meet some fascinating people, it also changed my perception of my art and in the process made me a better photographer, I hope.

The goal for this book was to show all aspects of Ireland's coast but unfortunately there is only so much space and no book of this size can do total justice to the wealth of subject matter. So in the end this is a personal view and I hope you enjoy looking at it as much as I enjoyed making it. Or as my countryman Heinrich Böll put it in his book *Irish Journal*:

'Es gibt dieses Irland: Wer aber hinfährt und es nicht findet, hat keine Ersatzansprüche an den Autor' ('This Ireland exists: However if you go there and can't find it, the author will not be responsible for compensation').

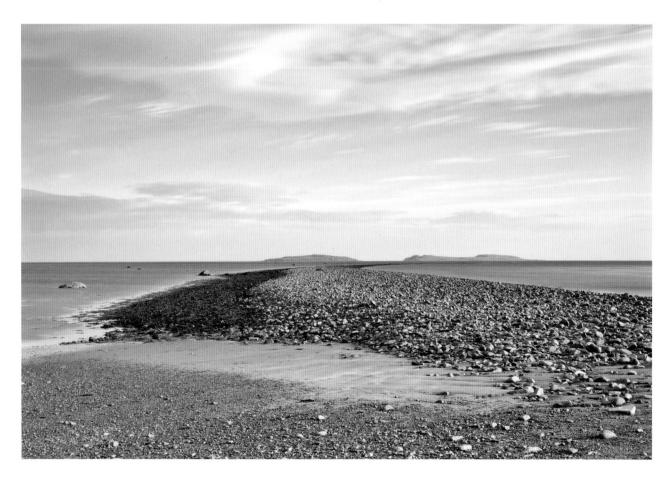

Above: The Saltees from St Patrick's Bridge, County Wexford

THE SOUTH EAST

The counties of Wexford and Waterford occupy the southeast corner of Ireland, an area also known as the sunny southeast. Statistically this part of Ireland enjoys more sunshine than the rest of the country, a very welcome fact for the outdoor photographer.

The far southeastern corner of Wexford is more or less one endless stretch of beach, starting at Wexford Bay on the eastern coast and ending at Ballyteige Bay in the south. Wexford Harbour at the Slaney Estuary is almost entirely surrounded by sandbanks that only leave a small opening between Raven Point in the north and Rosslare Point in the south. The Wexford Slobs, an area of reclaimed land known as polders, and the natural estuarine habitats of Wexford Harbour are a very important wintering place for wildfowl. Each year around 20,000 birds spend the winter season here. Photographing wildlife in Ireland in winter calls for luck with the weather and the light, and unfortunately my visits always coincided with grey and wet winter weather.

Further south lays another haven for birds: The Saltees. These rocky islands host Ireland's second largest gannet colony and are a breeding ground for several other bird species, like puffins, guillemots, fulmars and razorbills, and for grey seals.

West of the Saltee Islands the Hook Peninsula stretches out into the Celtic Sea and marks a change in the coastal landscape. Rocky shores grow into sheer cliffs that open up into secluded bays protected by protruding headlands and sea stacks: Waterford's Copper Coast.

Exploring Ireland's south east coast takes some effort. Although the coast runs in quite a straight line, the narrow country roads – which are especially picturesque in early summer when the banks are covered in pink flowers known as thrift – endlessly twist and turn before they reach the sea. I lost my way more than once and equally often I wasn't sure if I had reached the destination I had in mind. But in the end this didn't matter. I found enough subject matter to fill several books and the sunny southeast lived up to its name many times.

Situated around five kilometres off the south Wexford coast and built on bedrock laid down two- to six-hundred million years ago, the Saltee Islands are one of Ireland's natural wonders. The name given to the Great Saltee and its companion Little Saltee is probably of Norse origin, 'salt-øy', meaning 'salt island'. A visit to the Great Saltee in windy weather when salt spray quickly encrusts anything will reveal the reason for the name.

The Great Saltee is privately owned by the Neale family. The late Michael the First made a vow as a ten-year-old that one day he would own the Great Saltee. In 1943 he realised his dream and in 1956 he was crowned the first prince of the Saltees. In reality however the island belongs to the birds: the elusive Manx shearwater, razorbill, guillemot, kittiwake, gannet, puffin, cormorant and other species occupy every inch of the island during spring and summer. In autumn more than 100 grey seals also come to the island to breed. Unless you suffer from ornithophobia or have been watching Hitchcock's *The Birds* recently a visit to the island is an amazing experience.

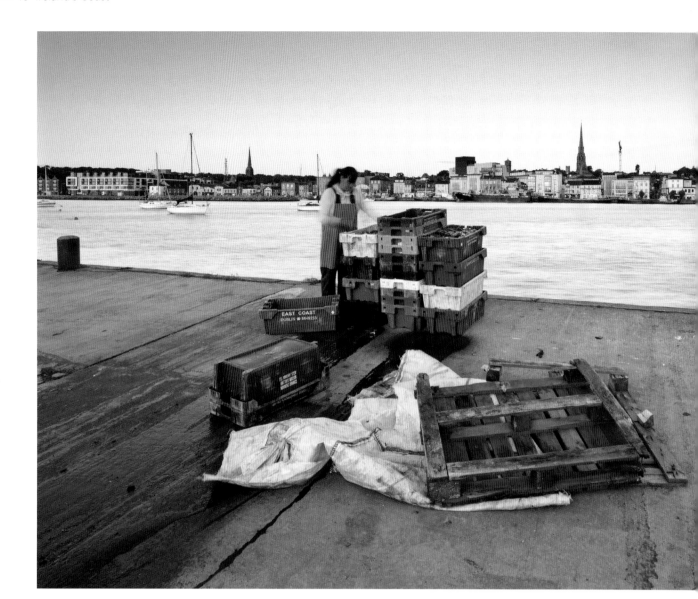

The Hook Lighthouse is not only one of Ireland's best known landmarks situated in beautiful surroundings, it is also one of the world's oldest working lighthouses, and Ireland's earliest established lighthouse.

The origins of Hook Lighthouse date back to the 5th century AD when St Dubhan, a Welsh monk, established the first beacon on Hook Head. St Dubhan, whose name is the Irish for 'fishing hook', had founded a monastery nearby and soon became aware of the dangers that the waters around Hook Head held for sailors. The first beacon wasn't much more than a fire built on top of a pile of stones but it provided a crucial guiding light for vessels entering Waterford Harbour.

Left page: Fisherwoman at Wexford Harbour, County Wexford
Right page: Kilmore Quay Harbour, County Wexford

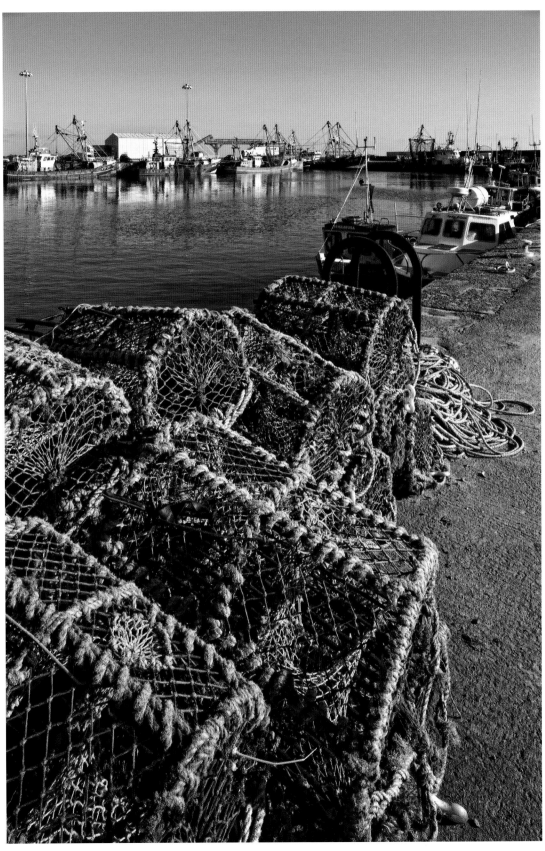

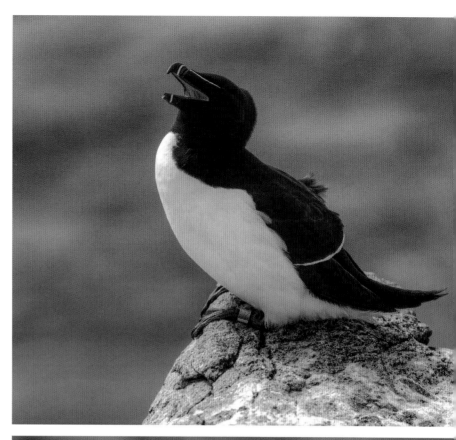

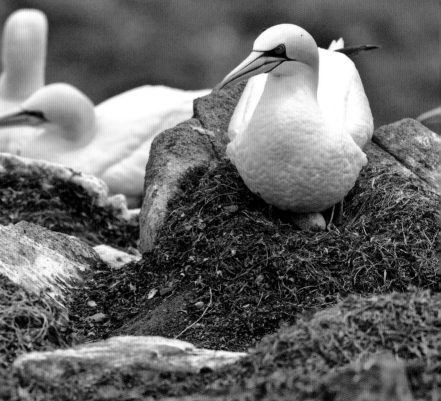

Left page top: Razorbill
Left page bottom: Gannets on the
Great Saltee
Right page: Puffin

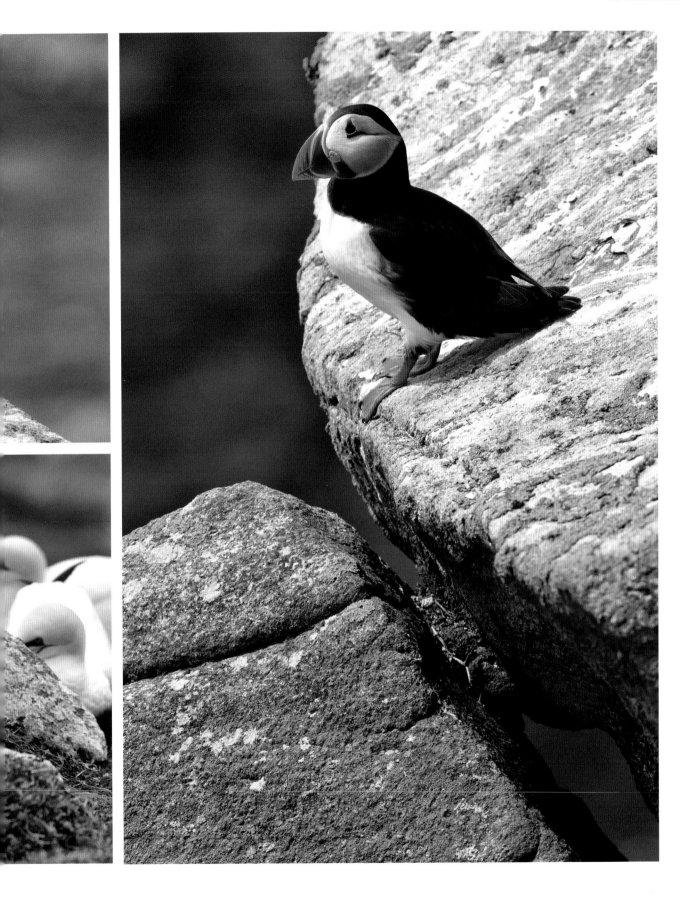

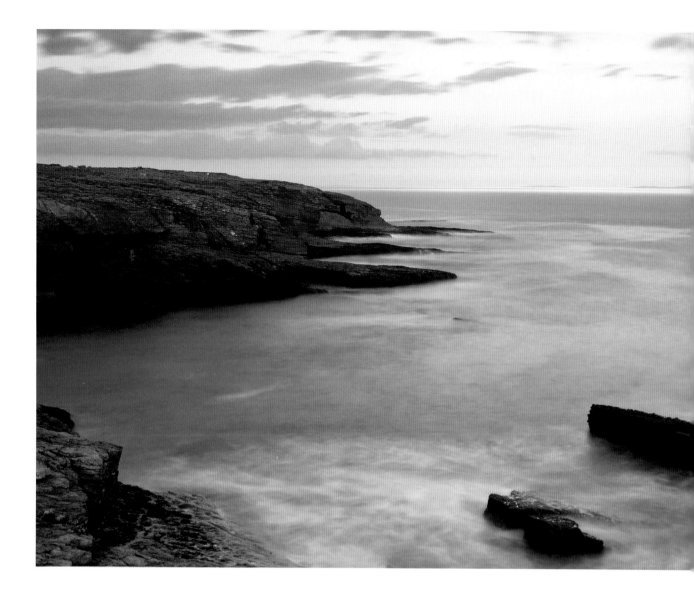

The first proper lighthouse was built in 1172 by Raymond LeGros, a Norman nobleman, who also used the tower to guard the entrance to the harbour and protect his land from invasion. LeGros however never saw the building finished and entrusted it to the local monks of the priory of St. Augustine before his death. Hook Lighthouse was eventually finished in the thirteenth century by William Marshall, the Earl of Pembrokeshire, and the monks continued to man the tower until 1641 when civil war broke out and they were forced to abandon the lighthouse.

It took twenty years and numerous shipwrecks to re-establish Hook Lighthouse, but in 1667 the light started to shine again and has done so ever since. In 1996 the light became automated and only five years later Hook lighthouse opened its doors to visitors and has become a major tourist attraction since.

A structure as old as Hook Lighthouse is unsurprisingly surrounded by numerous legends and stories. Various lighthouse keepers have reported the noise of footsteps during the night and one man even claimed to have seen the ghosts of the monks who had presided over the tower in the past.

Other stories claim that gold brought to Ireland by the Knights Templar is hidden in some secret room or within the walls of Hook Lighthouse.

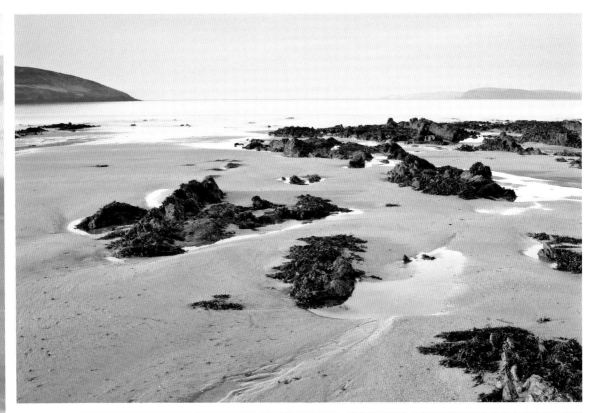

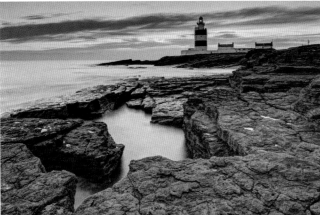

Right page top: Booley Bay, Hook Peninsula, County Wexford
Right page bottom: Hook Lighthouse, County Wexford
Left page: Hook Head Coast with Saltee islands in the distance, County Wexford

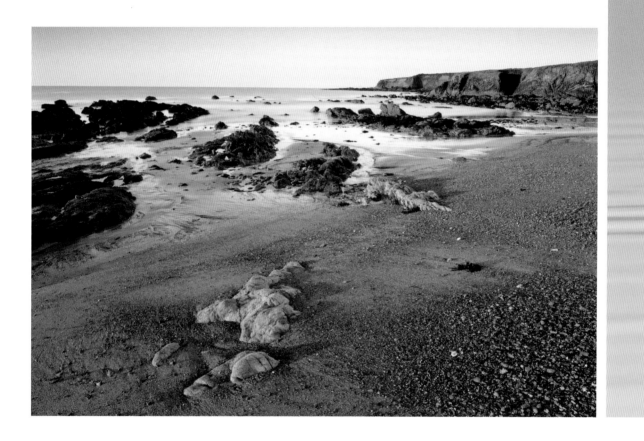

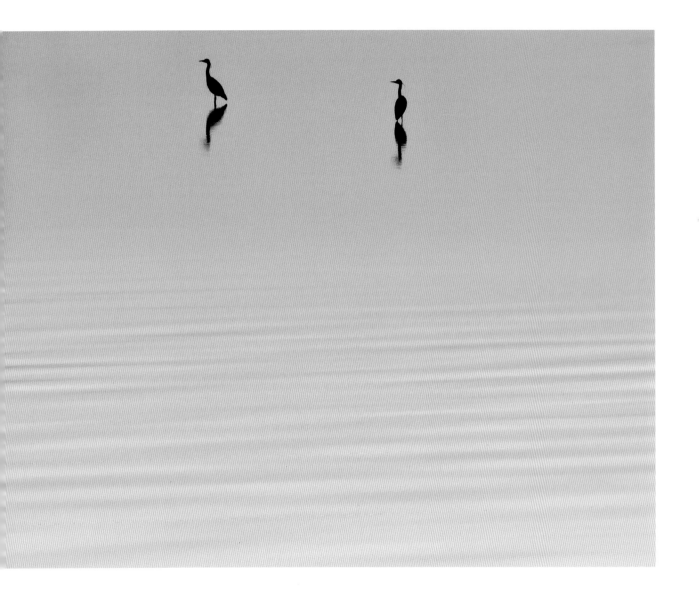

Right page: Herons and dusk, Bannow Estuary, County Wexford
Left page: Blackhall Strand, County Wexford

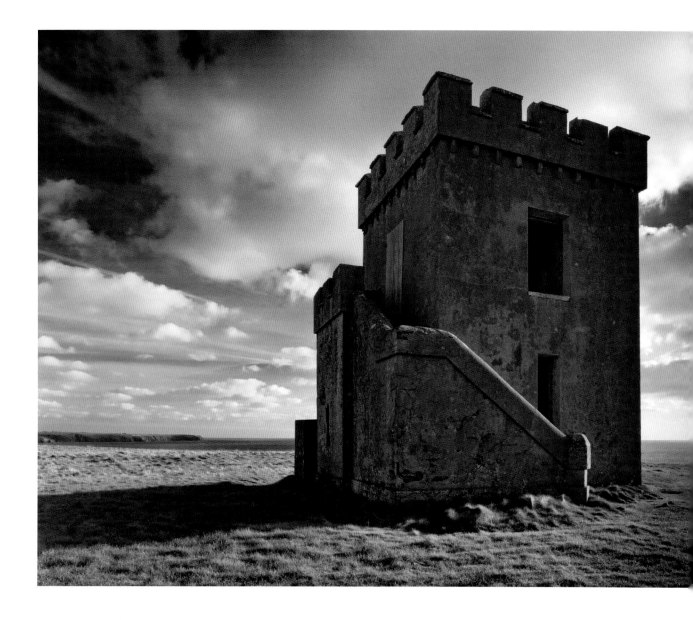

Left page: The Castle, Ram Head, County Waterford
Right page: Tramore Harbour Lighthouse, County Waterford

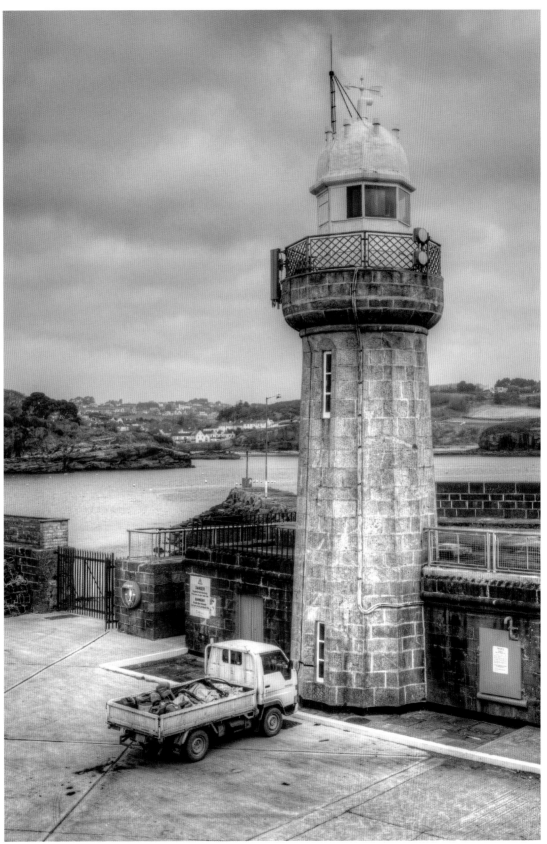

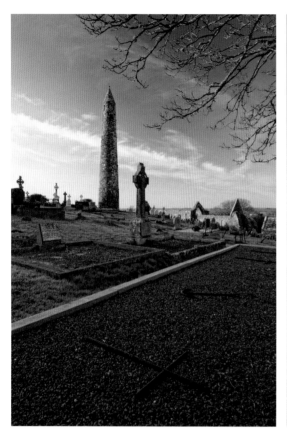

Ardmore is well known for its church and twelfth-century round tower. In a corner of the graveyard that surrounds both, a plain patch of gravel can be found, only decorated by some simple metal crosses and an anchor. Known as the Sailors' Grave, this resting place holds the remains of the twelve crewmembers of the S.S. *Ary*.

On 8 February 1947, the S.S. *Ary* left Port Talbot in South Wales with a crew of fifteen and a cargo of coal destined for Waterford Harbour. The winter of 1947 was one of the coldest and harshest on record in the UK and Ireland. Biting easterly gales and unprecedented snowfall held Western Europe in its grip for weeks. In these conditions the S.S. *Ary* set sail. Only a few hours into the journey the already bad weather worsened. The high seas caused the cargo to shift, destabilizing the vessel. All countermeasures taken by the crew were in vain and sometime after nightfall the order to abandon ship was given. All crewmen made it safely into the lifeboats before the S.S. *Ary* sank. During that cold and stormy February night onboard the lifeboats, all but one man died from exposure.

On Wednesday 12 February Jan Dorucki made his way up the northern side of Ardmore Bay. He was the only survivor. Later he recalled finding his crewmates frozen to death after the first night in the boat. Becoming nervous and afraid he decided to push the corpses into the sea. That Jan survived three days of sub-zero temperatures and stormy seas in a small lifeboat on the open water is nothing short of a wonder.

Over the following days the dead bodies of twelve sailors were washed ashore. They were buried together on the 18 February at Ardmore cemetery. The other two sailors have never been found.

The Copper Coast makes up the major part of the Waterford coast and stretches from Tramore to Dungarvan. Dramatic cliffs and sheltered coves with sandy beaches make this one of Ireland's most picturesque locations.

The Copper Coast, a designated European Geopark, gets its name from the nineteenth-century copper mines, remains of which can be found all along the coast. The Copper Coast can best be described as an outdoor geology museum that allows us to look back on 460 million years of earth's history. Volcanic eruptions, ancient deserts, deep river valleys and immense glaciers all left their mark in the cliffs of the Copper Coast.

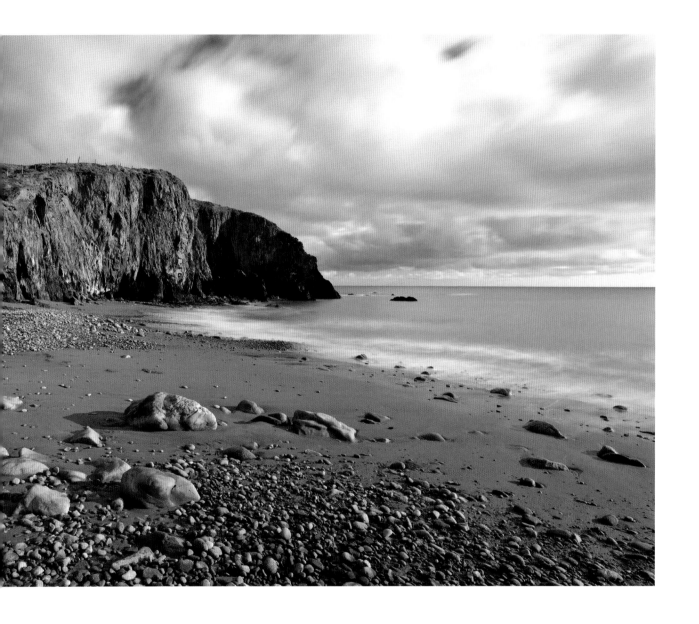

Left page: Sailors' Grave and Roundtower, Ardmore, County Waterford
Left page and right page: Ballyvooney Cove, Copper Coast, County Waterford

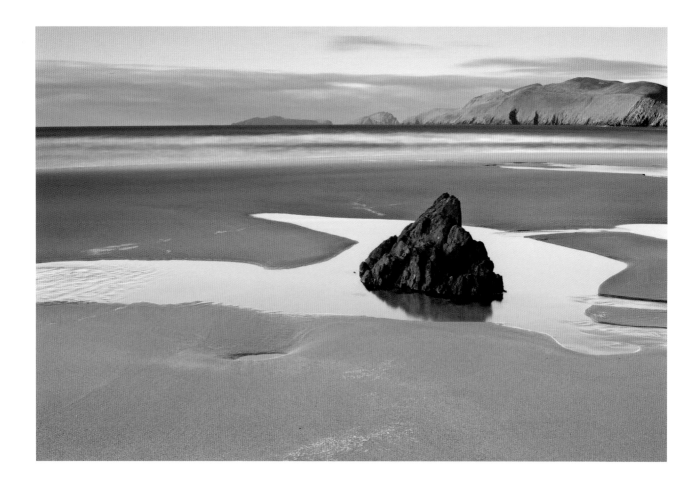

Above: Coumeenoole Bay and Great Blasket, County Kerry

THE SOUTH WEST

Ireland's southwest is caressed by the warm waters of the Gulf Stream and also receives a lot of water from above in the form of mist, drizzle, rain and various other forms of precipitation. The resulting mild and moist climate turns the counties Cork and Kerry into a natural garden with a plant life unlike anywhere else. Lush woodlands that seem to have come right from the Mediterranean cover valleys, hillsides and expand right down to the seashore.

The Cork coastline starts at Youghal and meanders in and out forming tiny bays, inlets, coves and harbours that are punctuated by headlands and promontories.

North of Baltimore these promontories grow bigger and become more defined. Mizen, Sheep's Head, Beara, Iveragh and Dingle are the great peninsulas of the southwest reaching out into the Atlantic Ocean like fingers. These peninsulas are divided by long stretched bays: Dunmanus Bay, Bantry Bay, Kenmare River and Dingle Bay are former river valleys that became flooded when the glacial ice sheets of the last ice age melted.

The Dingle Peninsula, once described, as 'the most beautiful place on earth' by *National Geographic Traveler*, and the Iveragh Peninsula, better known as 'The Ring of Kerry', have become major tourist attractions; the coastal drives around these promontories are world famous and during the summer months it is often stop and go on the narrow roads.

The other peninsulas are less overrun by visitors, but equally pleasing to the eye. Sandy beaches and sheer cliffs are dramatically backdropped by the spectacular mountain ranges that form the backbones of every single of the peninsulas. A book on West Cork published some years ago is entitled *A Place Near Heaven* and I couldn't think of any phrase more appropriate to describe the southwest.

From left to right: Fish, Dingle Harbour, County Kerry. Fishing nets, Coolmain Bay, County Cork. Seaweed and jellyfish, County Cork

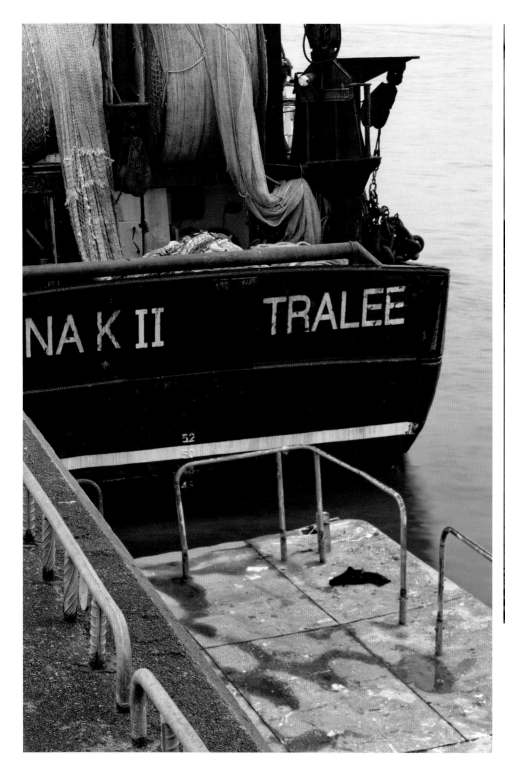

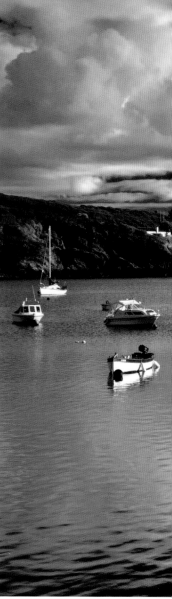

Left page: Trawler, Dingle Harbour, County Kerry
Right page top: Castle Haven, Castletownsend, County Cork
Right page bottom left: Toehead Bay, County Cork
Right page bottom right: Storm and Lighthouse, Galley Head, County Cork

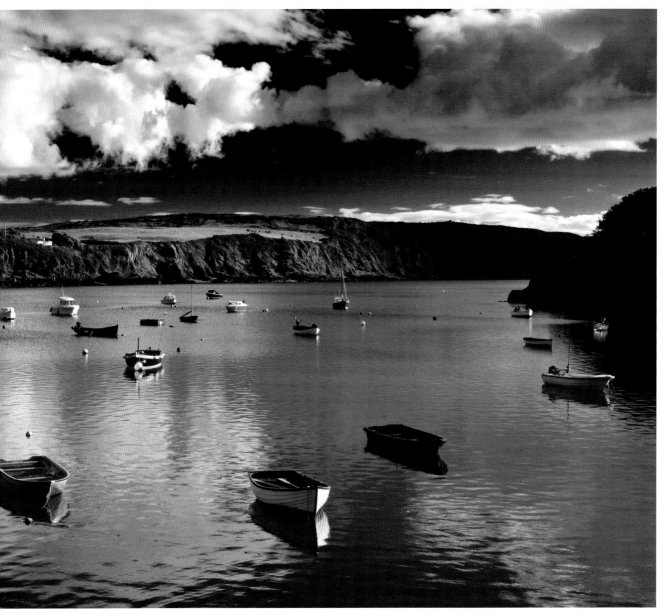

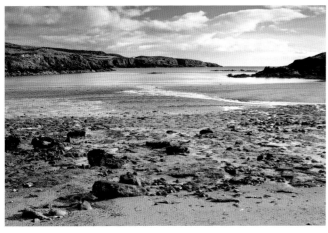

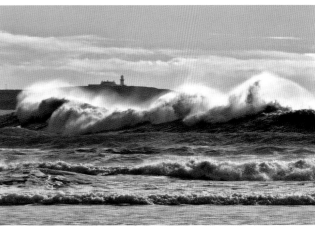

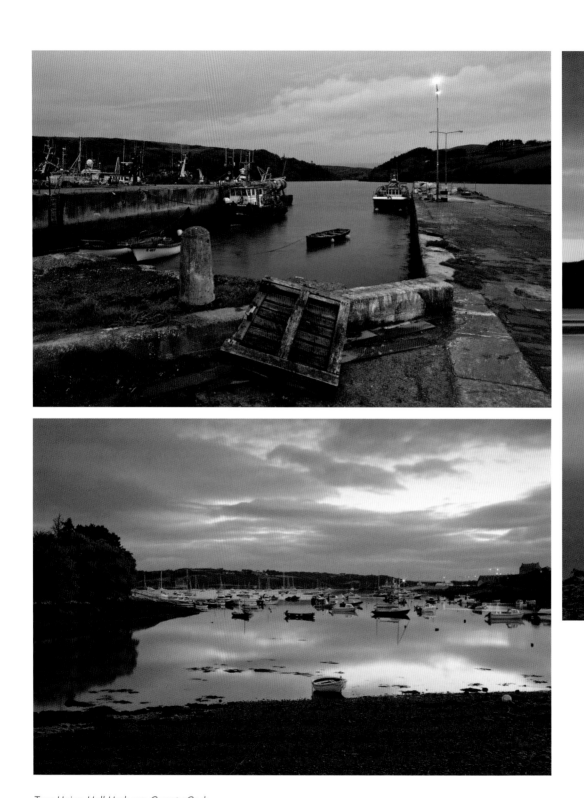

Top: Union Hall Harbour, County Cork
Bottom: Baltimore Harbour, County Cork

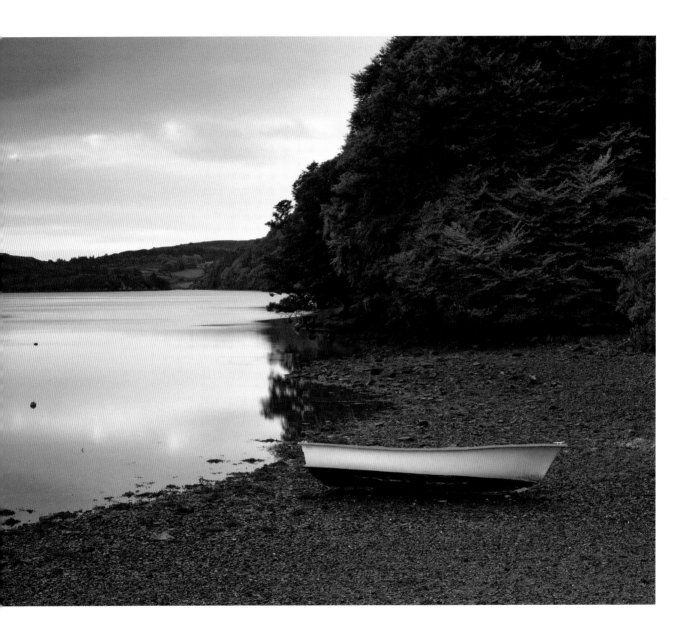

Lough Hyne is a saltwater lake located in the very southwestern corner of County Cork. It is a truly unique place seemingly insulated from the world by the surrounding hills and forests that provide shelter from all but the most severe winds. The lake is connected to the Atlantic Ocean only by a narrow tidal channel known as 'The Rapids' that provides the water exchange between the lake and open sea. This makes Lough Hyne essentially a giant rock pool with a rich flora and fauna. The lake has been studied extensively since the 1930s and was declared Ireland's first marine nature reserve in 1981.

Above: Lough Hyne, County Cork

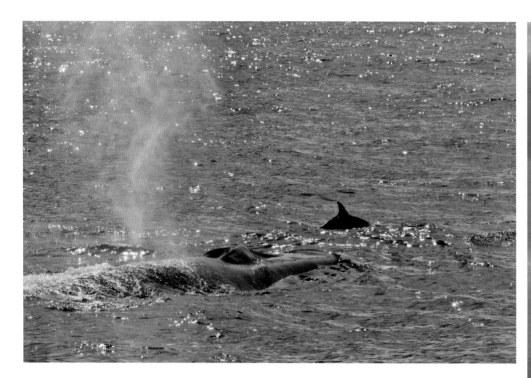

In the summer of 1631 Baltimore fell victim to what is thought to have been the worst ever pirate attack in Ireland. Earlier that year two ships under the command of a renegade Dutchman known as Morat Rais the Younger had left Algiers. Before reaching the Irish coast they had already seized several smaller vessels and killed or imprisoned their crews.

In the early hours of that fateful summer morning more than two hundred corsairs landed in the cove, burning houses and carrying off with its inhabitants. More than a hundred men, women and children had been taken and most of them never heard of again. The most likely scenario is that they ended up at the North African slave markets and spent the rest of their days as galley slaves or concubines in the harems.

The beacon overlooking the entrance to Baltimore Harbour was erected in 1849 as a warning sign to seafarers and is a notable landmark in the area. The more than fifteen-metre high structure is also known as 'Lot's Wife' or 'Pillar of Salt' for obvious reasons.

Across the narrow channel lies Sherkin Island, one of the many islands of Roaringwater Bay (the most beautifully-named bay in the whole of Ireland in my opinion), with its lighthouse that marks the other side of the narrow entry to Baltimore Harbour.

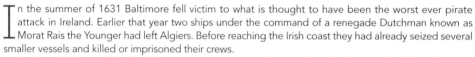

Above: Fin whale and common dolphin off the Kerry Coast

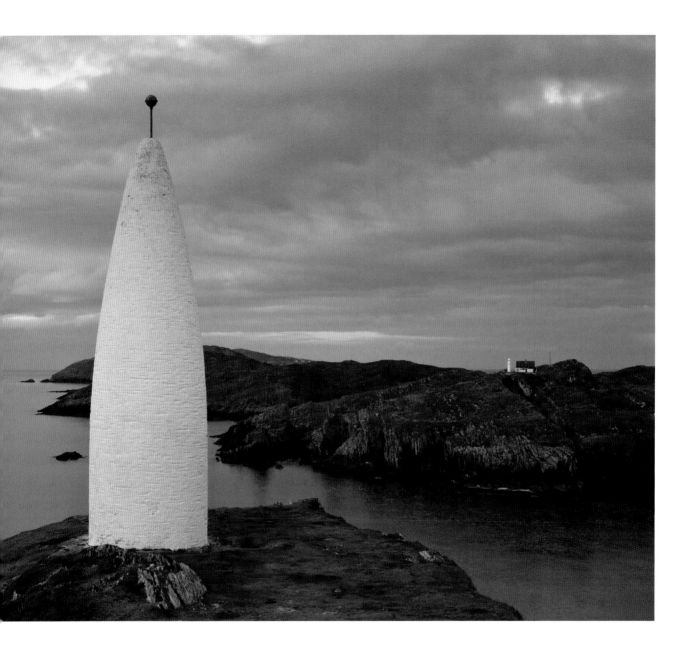

Above: Baltimore Beacon and Sherkin Island, County Cork

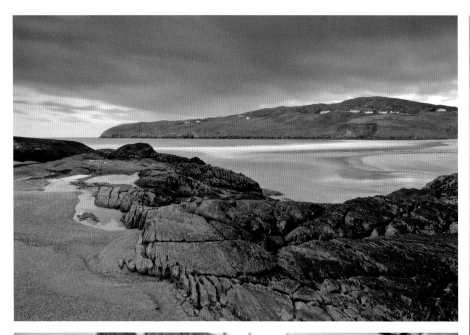

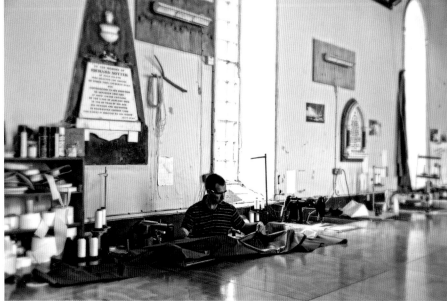

J ust outside the village of Goleen on the Mizen peninsula Christophe Houdaille has set up his
workshop in a most unusual location; Christophe is a sail maker and he runs his business out
of a deconsecrated church. Needless to say I was thrilled when Christophe allowed me to
visit him and his team. Photographing a craftsman in such a unique setting is something special.

Above: Barley Cove, Mizen Peninsula, County Cork
Below: Christophe Houdaille of Fastnet Sails, Goleen, County Cork

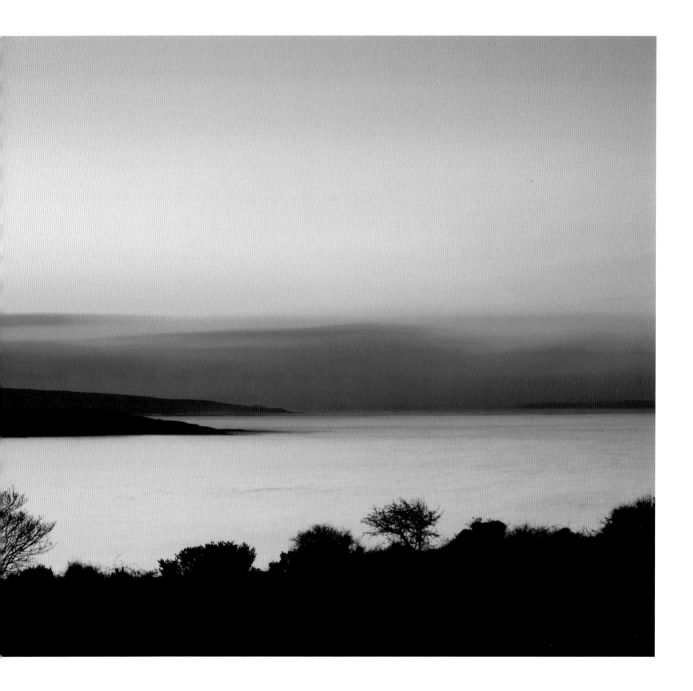

Christophe is one of only a handful of traditional sail makers in Ireland. After learning his craft and sailing around the world for eight years he settled in Ireland and established his own business, Fastnet Sails, in 2003.

While chatting away about regattas, boats and his work I also learned that Christophe had been assigned to make the sails for the *Seol Sionna* boat building project I was documenting in County Clare. A typical Irish coincidence!

Above: Dawn at Schull Harbour, Mizen Peninsula, County Cork

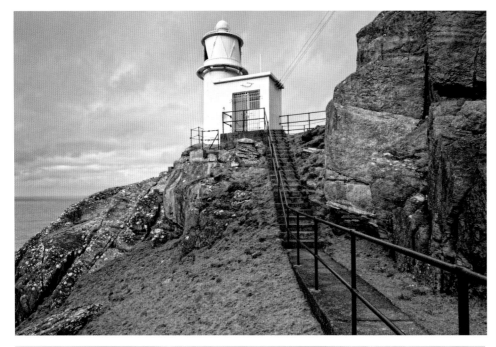

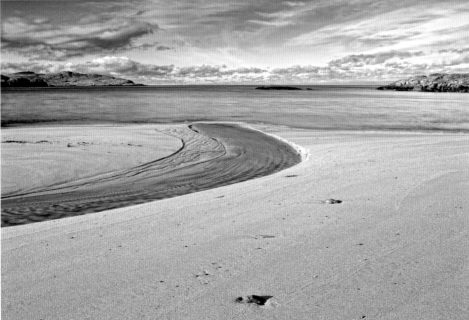

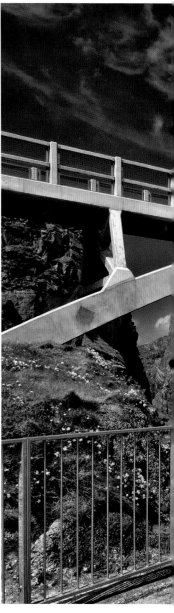

Right page: Mizen Head Bridge, County Cork
Left page top: Sheep's Head Lighthouse, County Cork
Left page bottom: Ballydonegan Strand, Beara Peninsula, County Cork

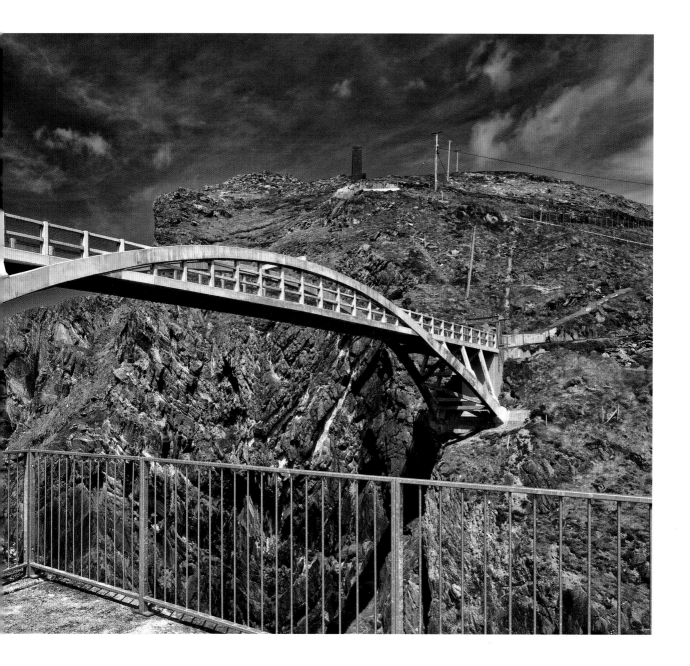

Mizen Head Lighthouse stands on a rocky outcrop connected to the mainland by a reinforced concrete suspension bridge. The original bridge, the first of its kind in Ireland, was built in 1909 to allow the lighthouse keepers easy access to their workplace. After the lighthouse was automated in 1993 Mizen Head was transformed into a visitor center and the bridge became one of the major attractions.

After a hundred years of service, however, the extreme weather and environmental conditions had taken their toll on this landmark building. The new bridge, pictured here shortly after completion, opened to the public in 2011. It is an exact replica of the old structure the only difference being the deck, which is now seventy centimetres wider.

The Beara Peninsula with its rugged coastline and carved mountain ranges is still a well-kept secret even after its northerly neighbours Iveragh and Dingle have been overrun by mass tourism for decades. This is both surprising and welcome especially if you take into account the fact that Beara more than rivals its neighbours not only in scenic beauty but also in a rich built heritage.

For a photographer Beara is a treasure chest and the only problem is the abundance of subject matter … and the weather. Due to its topography Beara creates its own microclimate and the official weather forecast is practically worthless. One half of the peninsula can be bathed in sunshine while the other half, only a short drive over the mountains, is being drenched.

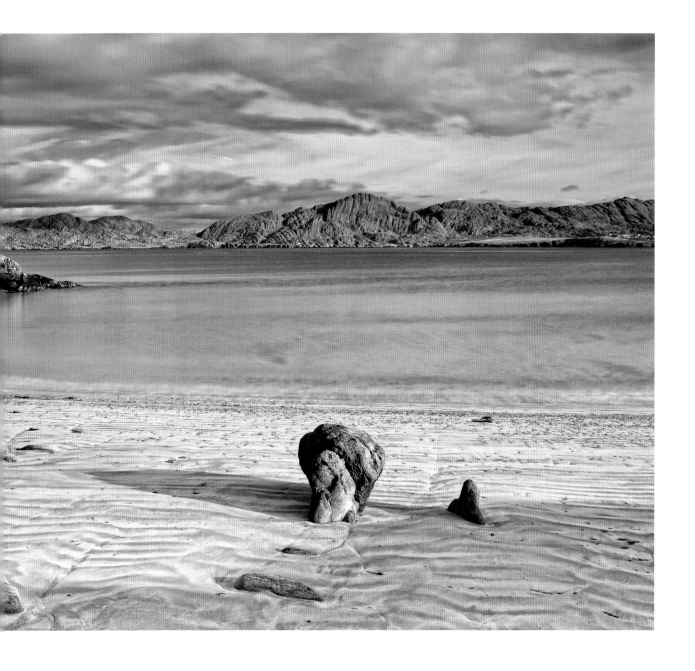

Left page 1st image: Loughaunacreen, Beara Peninsula, County Kerry
Left page 2nd image: Pallas Harbour, Beara Peninsula, County Cork
Right page: Garinish Strand, Beara Peninsula, County Cork

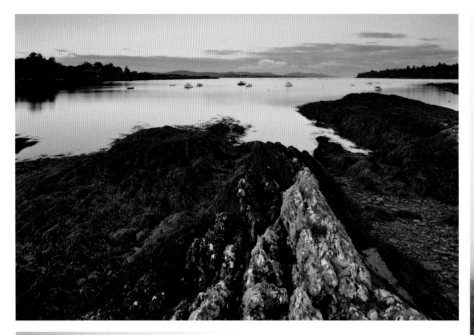

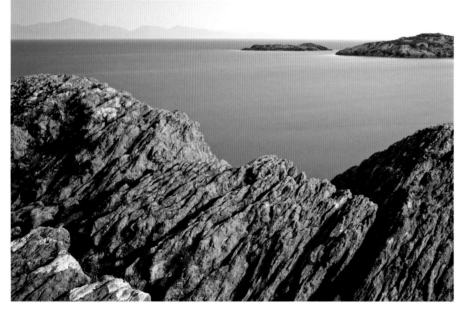

Top: Bantry Bay, County Cork
Bottom: Illauncrone, Iveragh Peninsula, County Kerry

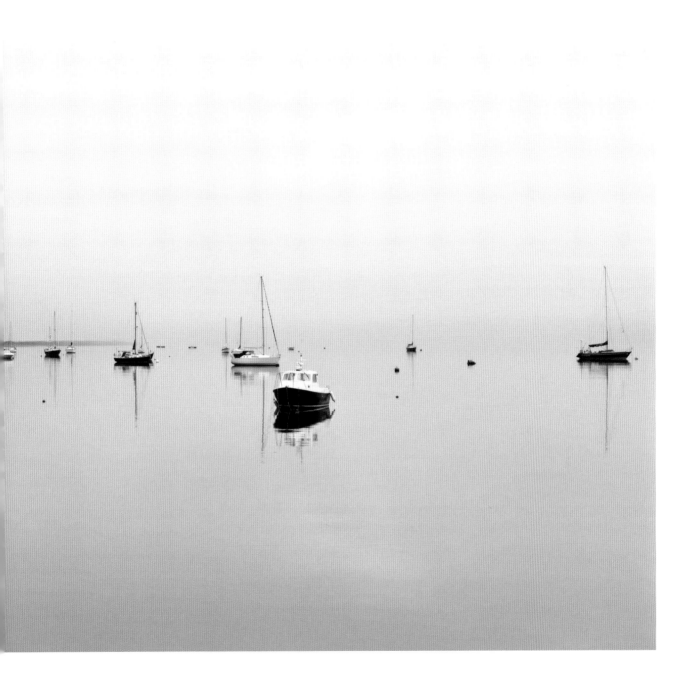

Above: Fog over Bantry Harbour, County Cork

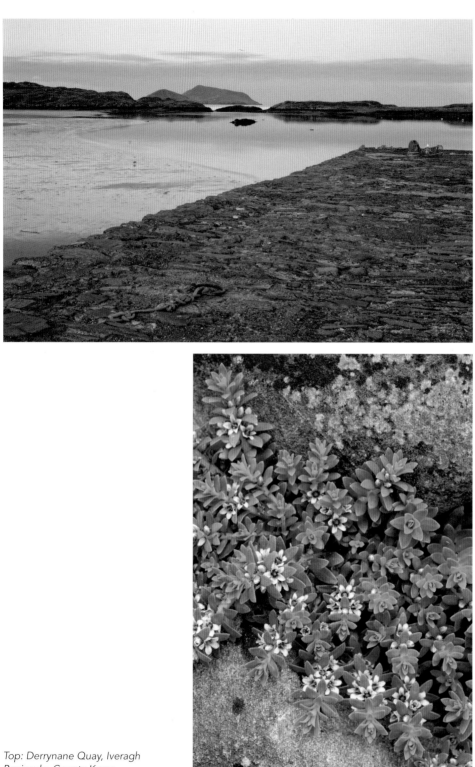

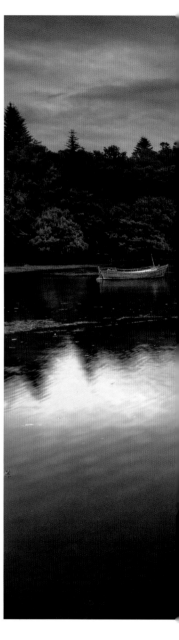

Top: Derrynane Quay, Iveragh
Peninsula, County Kerry
Bottom: Sea milkwort, County Kerry

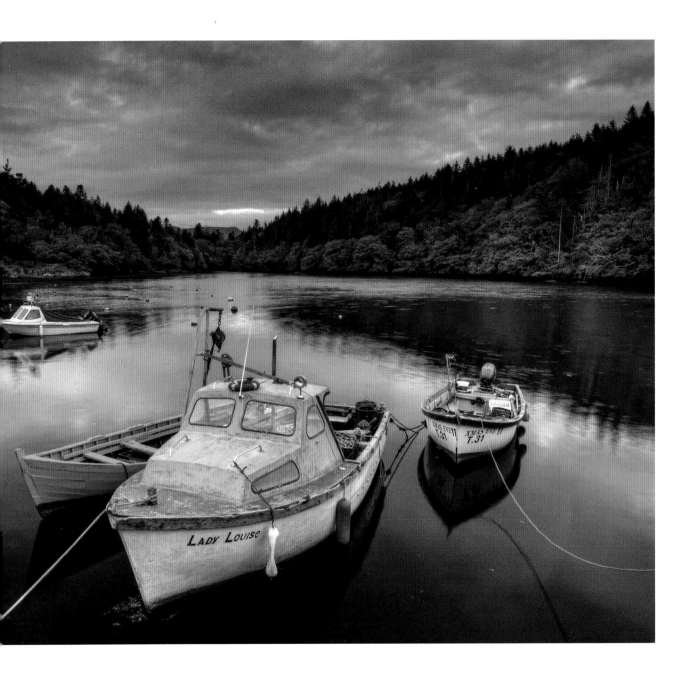

Above: Blackwater Estuary, Iveragh Peninsula, County Kerry

I don't consider myself to be a spiritual person but there are places where even I envisage the possibility of a greater entity, a global spirit or whatever you may call it. Skellig Michael is one of those places. This towering sea crag and its brother, Little Skellig, sit some twelve kilometres off the Kerry coast. Skellig Michael raises cathedral like to a height of over two hundred metres, Little Skellig reaches around 130 metres. Even from the mainland the shape of these rocks has considerable impact, they almost look like crowns rising out of the water, and make it clear there is something special about the place.

My first trip to Skellig Michael on a fine spring day coincided with perfect conditions. A calm sea (a rather rare event around the Skelligs), light winds and soft light filtered by clouds.

To reach the top of the island an almost vertical climb is necessary, following some six hundred steps that were built into the rock face sometime around the year 588 AD. For someone carrying several kilograms of photo equipment and suffering from vertigo this is not an easy trip. But the sheer spirit of the place makes it all worthwhile. Putting this 'spirit of the place' in words is something I have tried many times, but always failed. Words like 'tranquil', 'mighty', 'beautiful', 'mysterious' come to mind, but do nothing more than scratch the surface.

It is a place where it is easy to feel close to a greater power and not surprisingly Skellig Michael was home to a monastery for almost six hundred years between the sixth and thirteenth century AD. The buildings of this monastery still exist today and are in astonishingly good shape considering the power of the elements around the Skelligs. The six beehive huts, two boat-shaped oratories and a medieval church together with several stone crosses, slabs and graves make it easy to imagine early monastic life on this lonely outpost.

To call this life hard would be an understatement. The lack of wood or turf would have made heating and cooking difficult to. There was fresh water and just enough soil to run a small vegetable garden. During spring and summer there were birds and eggs but in autumn and winter this food source disappeared and even fishing must have often been impossible due to the regular occurring violent storms. But maybe bodily comfort becomes of less importance in a place like this.

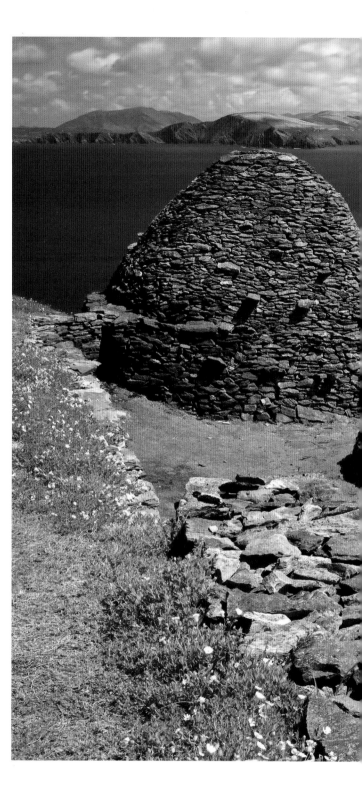

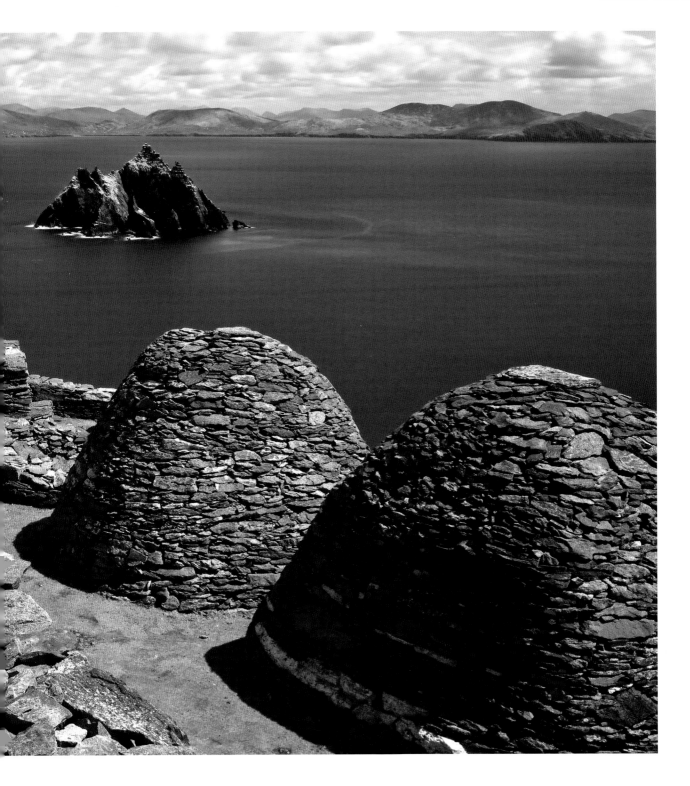

Above: Monastery on Great Skellig with Little Skellig in the background, County Kerry

The Blaskets are an island group off Slea Head on the Dingle Peninsula. In the 1920s and 1930s several books emerged from the community of the Great Blasket, written in the Irish language and describing everyday life on the island.

Peig Sayers, Muiris Ó Súilleabháin and Tomás Ó Criomhtháin are probably the best known and their books *Peig*, *Twenty Years A-Growing* and *The Islandman* have been translated into several languages and are deemed classics in literature.

There never was a big community on the Great Blasket. At its height in 1916 the population reached no more than 176 people and after that it declined steadily mainly due to emigration. In 1953 the last remaining twenty-two inhabitants left the Great Blasket for good.

The Irish Seal Sanctuary is dedicated to the rescue and rehabilitation of all marine wildlife but is, as the name suggests, particularly concerned with abandoned, injured, distressed or malnourished seals.

The ISS was founded in 1986 by Brendan Price, who was also a founding member of the *Irish Whale and Dolphin Group*. For 20 years the ISS was run out of Brendan's back garden in Balbriggan, Co. Dublin. After Fingal County Council withdrew the funding for a planned marine conservation facility the ISS had to start looking for a new home.

Above: Templenoe Pier, Kenmare River, County Kerry
Opposite Top: Between sea and sky, Slea Head and Blasket Islands, County Kerry

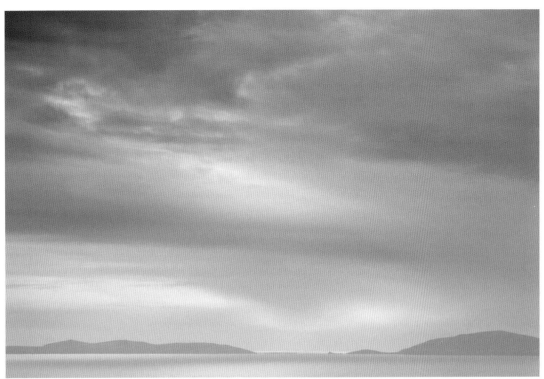

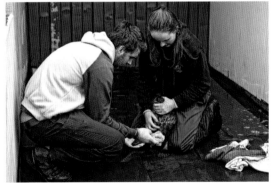

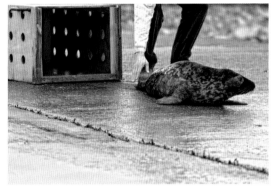

In 2006 the sanctuary was eventually offered a three-acre site close to the beach at the Gorey-Cour-town Forest Park in County Wexford. The plan was not only to extend the facilities but also built a visitor center, which would create vital funding for the ISS.

In 2011 however staff of the sanctuary found themselves locked out of the facility after an escalating dispute between the owners of the site and the ISS. At the time of writing the ISS is still homeless and most of the rescued seals are treated at the *Dingle Wildlife and Seal Sanctuary*. At times, it can seem like groups like the ISS are fighting a losing battle against cruelty and ignorance: the heads of two slaughtered seals were nailed at the entrance of the *Dingle Seal and Wildlife Sanctuary* in summer 2012, where I had photographed the work of the *Irish Seal Sanctuary* only weeks earlier. To date the ISS and its volunteers have rescued and treated more than eight hundred seals and are dealing with more than two thousand distress calls every year. In addition the ISS has made a real difference through an education program for schools and regular eco walks and talks; it is to be hoped that work of this kind will continue to change some people's attitudes towards the other creatures who share our world.

Above: The Dingle Seal and Wildlife Sanctuary, County Kerry

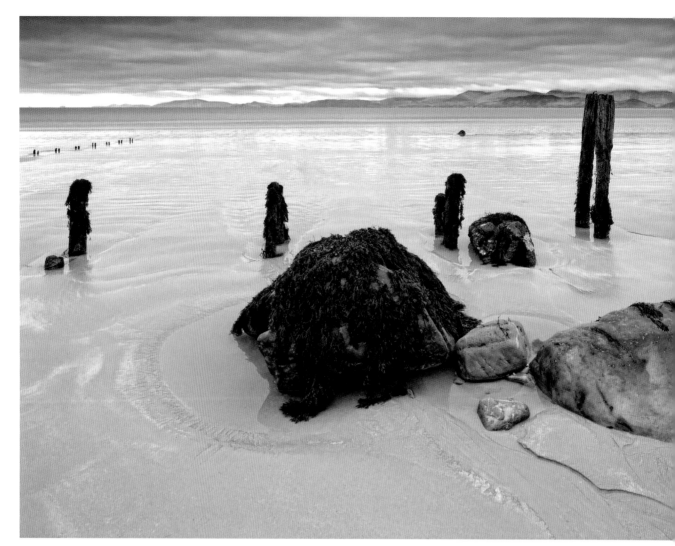

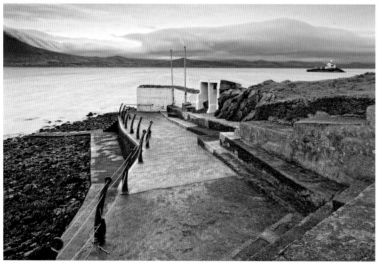

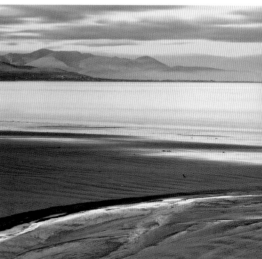

Left page top: Rossbehy Strand, Iveragh Peninsula, County Kerry
Left page bottom left: Dingle Peninsula from Fenit, County Kerry
Left page bottom right: Derrymore Strand, Dingle Peninsula, County Kerry
Right page: Abandoned houses and Blasket Islands, Dingle Peninsula, County Kerry

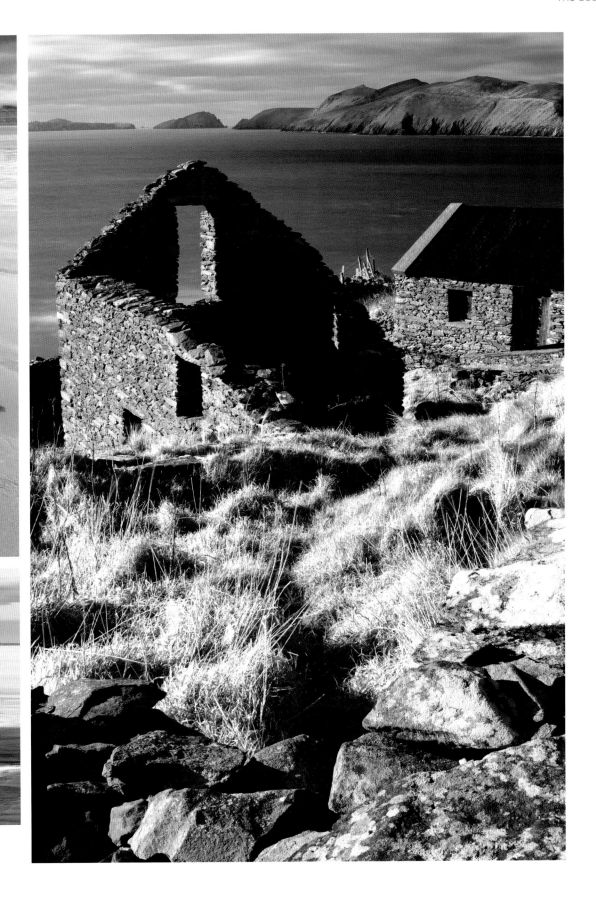

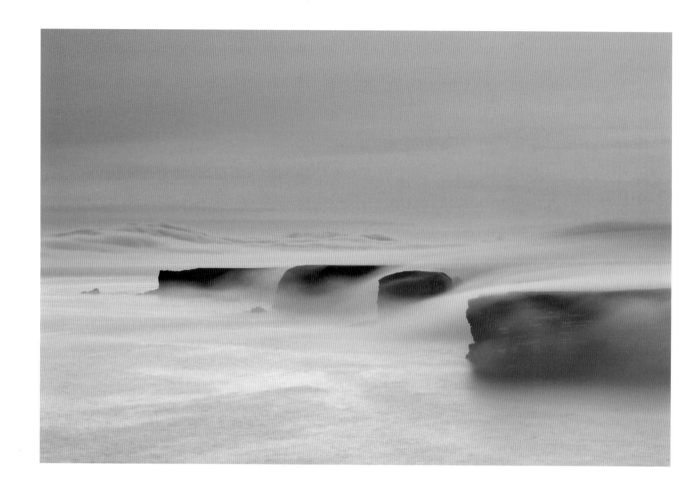

Above: Cliffs and fog, Loop Head, County Clare

THE WEST

The west, incorporating the counties Clare and Galway, is probably the most diverse part of Ireland's coast. The very south west of County Clare is formed by the Loop Head Peninsula, which borders at the estuary of Ireland's longest river, the Shannon. An incredible variety of habitats and landforms can be found here, mudflats, salt marshes, rocky and sandy shores and cliffs with sea stacks, rock arches and sea caves.

The relatively deep water and shelter from the Atlantic Ocean has made the Shannon Estuary an important centre for industry, imports and exports for Ireland. The industry includes two major power-generation plants at Moneypoint, County Clare and Tarbert, County Kerry and deepwater ports at Foynes and Limerick, which can accommodate vessels up to 20,0000 dwt (dead-weight tonnage).

In addition both sides of the estuary are dotted with countless fishing and leisure ports. Boat-based Dolphin Watching has become a major tourist attraction and during spring and summer regular tours leave from Kilrush and Carrigaholt on the Clare side of the estuary.

Once the Loop Head peninsula joins the mainland at the seaside resort of Kilkee, Clare's coast becomes a mix of rocky shores, cliffs and some of Ireland's finest surfing beaches like Lahinch and Spanish Point. North west of Lahinch, on a plateau that provides fine views over Clare's coast and countryside, lies one of the country's major tourist attractions: The Cliffs of Moher, eight kilometres of sheer rock dropping into the Atlantic Ocean.

Left to right: Coral strand, Connemara, County Galway. Cleggan shore, Connemara, County Galway. Sand and rock, Inishmore, County Galway

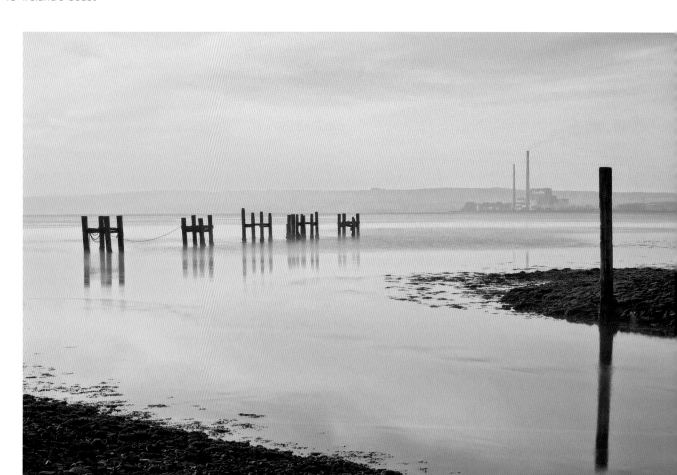

From here on the coastal scenery changes dramatically. The Burren is a limestone karst landscape renowed for its mingling of mediterranean, arctic and alpine flora and strange appearance. A mainly rocky shoreline is overlooked by grey, terrace shaped hills dotted with erratic bouders. There is, however, a break in the wild rocky shoreline at Fanore, where there is a broad sandy beach and adjoining dune system. Off the Burren coast the three Aran Islands lie like sleeping giants in the Atlantic Ocean: Inishmore, Inishsheer and Inishman are part of County Galway, but geologically they are an outpost of the limestone moonscape of the Burren.

Just north of Fanore the coastline makes a sharp eastern turn and opens up into Galway Bay. The eastern part of the bay that eventually leads to Galway City is a taste of things to come: small bays, peninsulas and islands form a calmer, more serene seascape.

Just outside the limits of Galway City lie the borders of one of Ireland's most famous landscapes: Connemara, named after 'Conmhaicne Mara', 'the descendants of the sea', is an incredible rugged landscape. A bird's-eye view looks like a giant has ripped out bits and pieces from the landscape, leaving behind torn and jagged fringes. Connemara's coastline twists and turns, forming countless small bays and tiny inlets, peninsulas and islands, which make exploring this unique place the challenge of a lifetime.

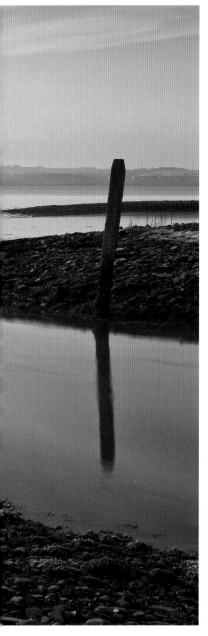

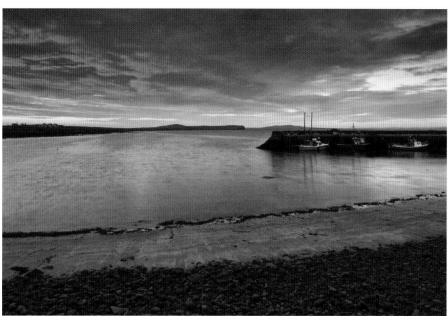

Opposite: Shannon Estuary at Killimer, County Clare
Top: Kilbaha Harbour, County Clare
Bottom Foynes Harbour, County Limerick

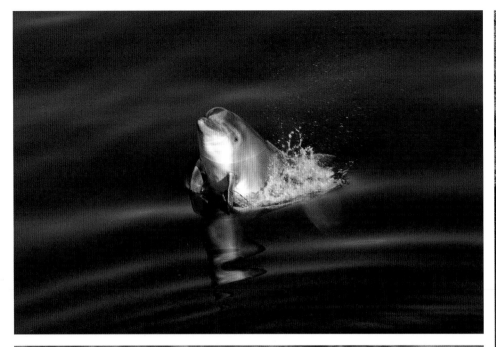

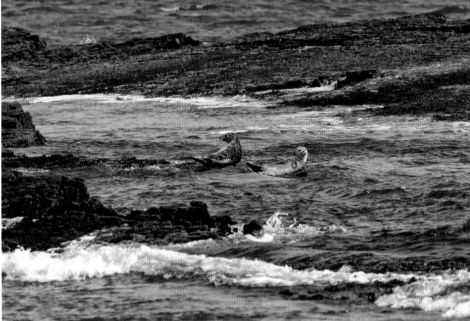

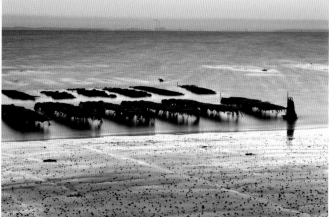

The Shannon Estuary is an incredible place for wildlife. Despite the fact that it is a major shipping lane with two major industrial ports at Foynes and Limerick and several smaller harbours along the way, nature is thriving here. The estuary is a feeding ground for thousands of seabirds; some nest on the cliffs of the Loop Head Peninsula, while some, like the gannet, come from as far away as the Skelligs to feed. Both common and grey seals live and breed in the area and the white coats of newborn grey seals are a regular sight in the storm caves around Loop Head.

The biggest attraction, however, is Ireland's only resident population of bottlenose dolphins. More than a hundred animals, locally known as the 'Shannon Dolphins', live in the area, taking advantage of the strong tidal currents that bring a constant food supply. Legends of sea monsters dating back many centuries might suggest that the dolphins' presence is no recent thing.

Left page top: The Shannon Bottlenose Dolphins
Left page bottom: Common Seals, Kilbaha Bay, County Clare
Centre: Thrift, Loop Head, County Clare
Right page top: Oyster Beds, College Strand, Loop Head
Peninsula, County Clare

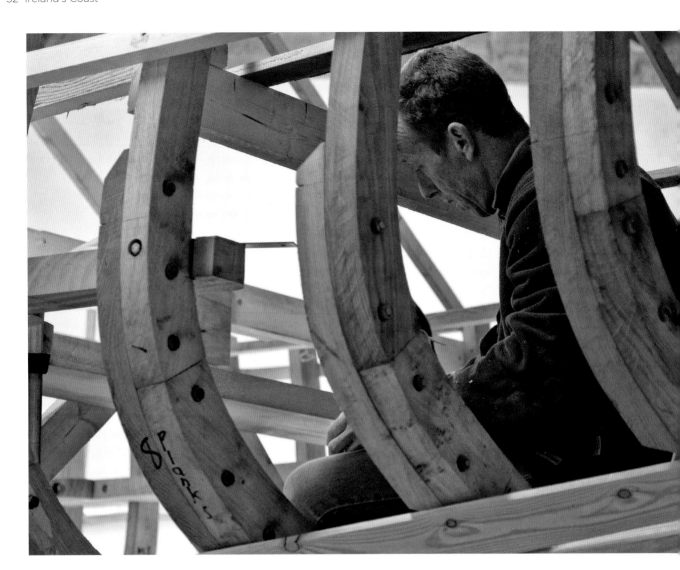

The tradition of boat building is still very strong in Ireland and traditional boats like the currach or the Galway hooker are a regular sight around Ireland's coast. Some boats, however, have almost disappeared into the mists of time. The wooden sailing boat of the Shannon Estuary, the Shannon Hooker, is one of them. They were once regular transport for people, livestock, turf, fish and other cargo up and down the estuary.

In 2010 the Seol Sionna project, whose name means 'Shannon Sail', was born to bring the traditional sailing boats back to the Shannon. In the small village of Querrin, which once had a fleet of twenty-five of these boats, the Sally O'Keeffe was built over a period of almost two years. Named after the lady who owned one of the last turf boats in the area in the 1800s, the Shannon hooker made a proud return to the waters of the Shannon on 19 May 2012.

Above: Building the Sally O'Keeffe, Querrin, County Clare
Opposite: Sally O'Keeffe maiden journey, Shannon estuary, County Clare

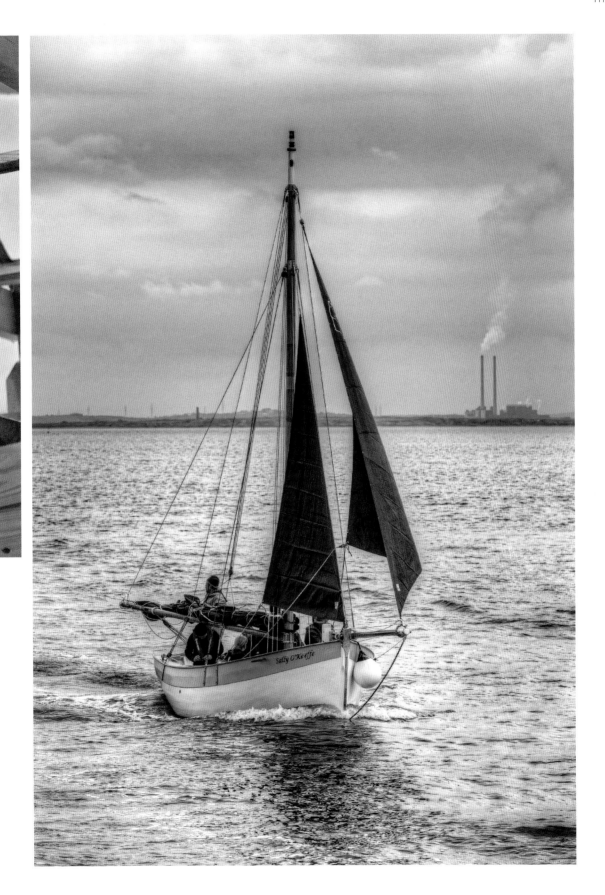

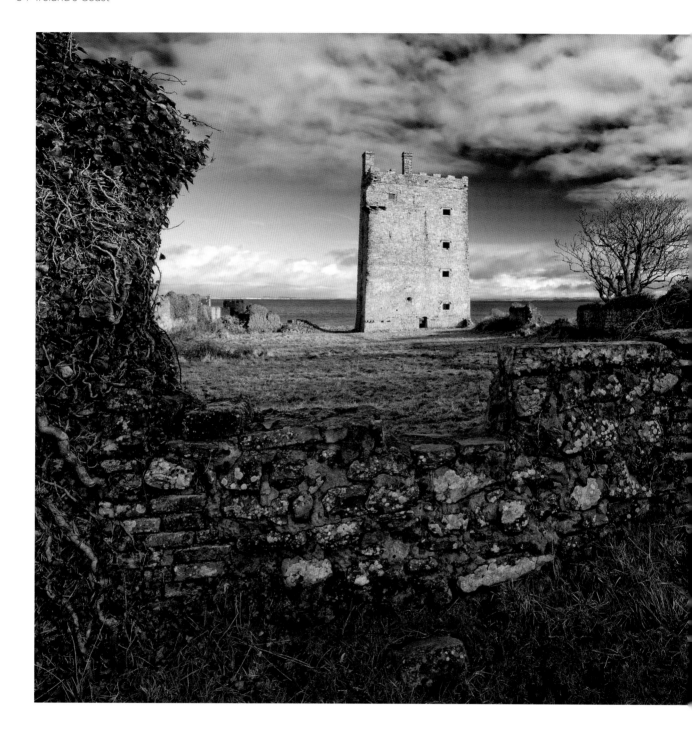

Left page top: Carrigaholt Castle, Shannon Estuary, County Clare
Right page top: Ross, Loop Head Peninsula, County Clare
Right page middle: Kilbaha Bay, County Clare
Right page bottom: Winter Storm, Loop Head, County Clare

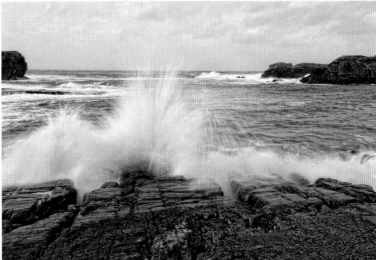

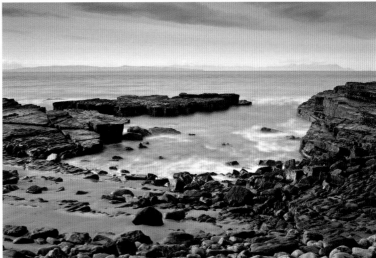

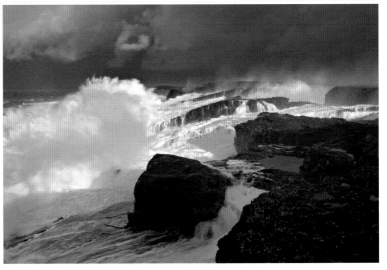

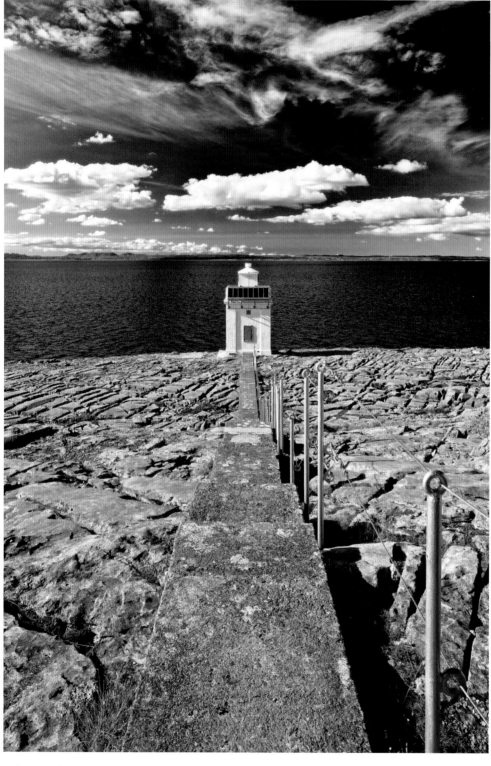

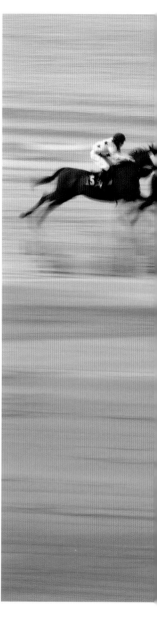

Left page: Black Head Lighthouse and Galway Bay, The Burren, County Clare
Right page: The Strand Races, Kilkee, County Clare
Right page bottom right: Kilkee Strand and West End, County Clare
Right page bottom left: Cliffs of Moher, County Clare

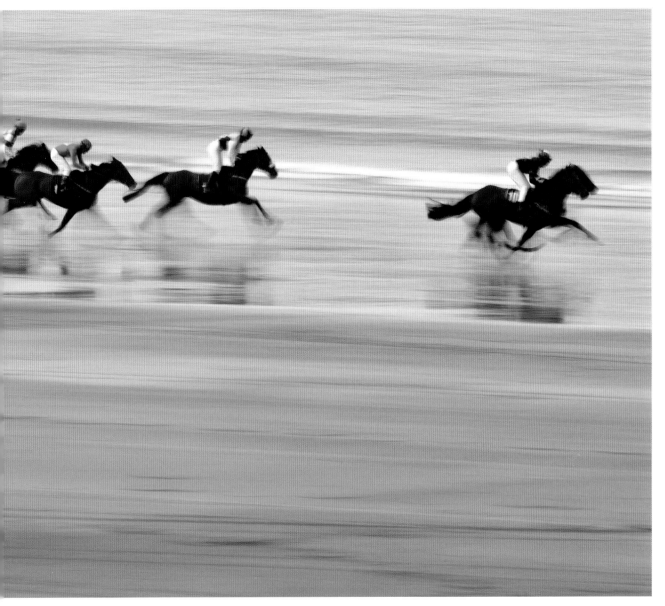

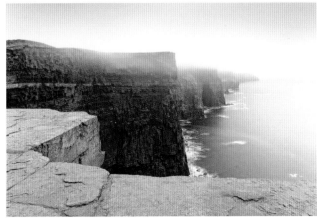

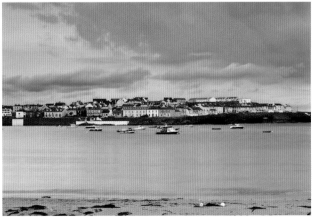

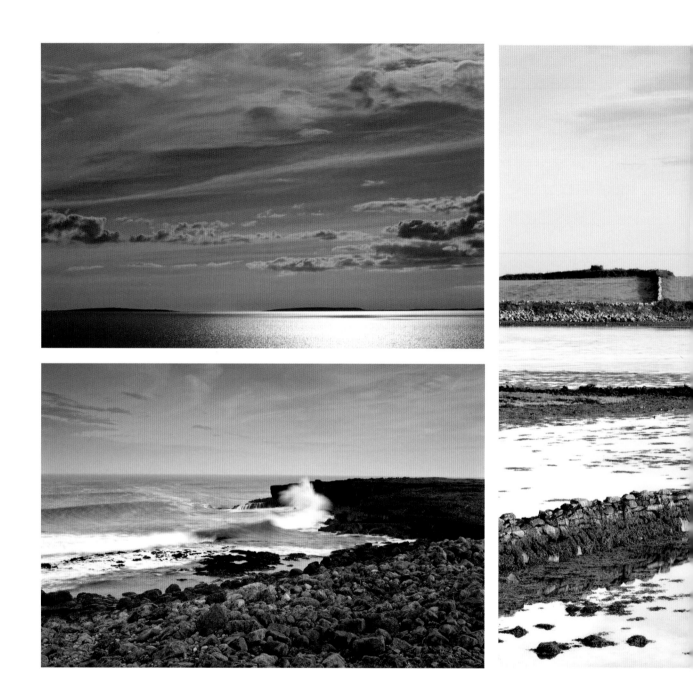

Top: Aran Islands seen from Black Head, The Burren, County Clare
Bottom: Ballyryan, The Burren, County Clare
Opposite: Aughinish and New Quay, The Burren, County Clare

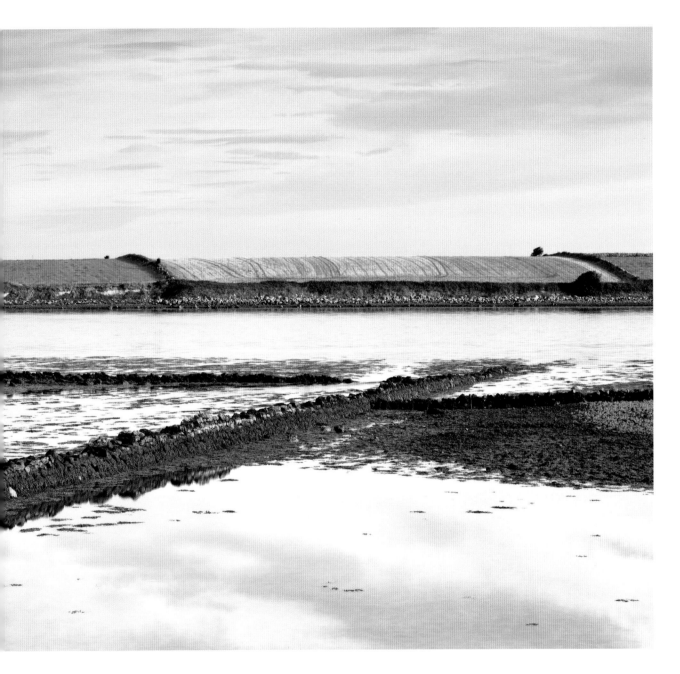

Around 150 years ago Kilkee was nothing more than a small fishing village, but when the wealthy aristocrats and merchants from the nearby city of Limerick started building summer residencies at the West End of the village, Kilkee started to attract visitors. During the eighteenth century Kilkee became one of the most famous seaside resorts in Ireland and still attracts thousands of visitors during the summer months.

Surrounded by sheer cliffs Kilkee's main attraction is the horseshoe-shaped beach, where horse races – the 'Strand Races' – are held every autumn. The beach is protected from the full force of the Atlantic by the Dugerrna Reef that stretches across the mouth of the bay. The reef is also home to the 'Pollock Holes', swimming-pool-sized rock pools that are very popular places to swim at low tide.

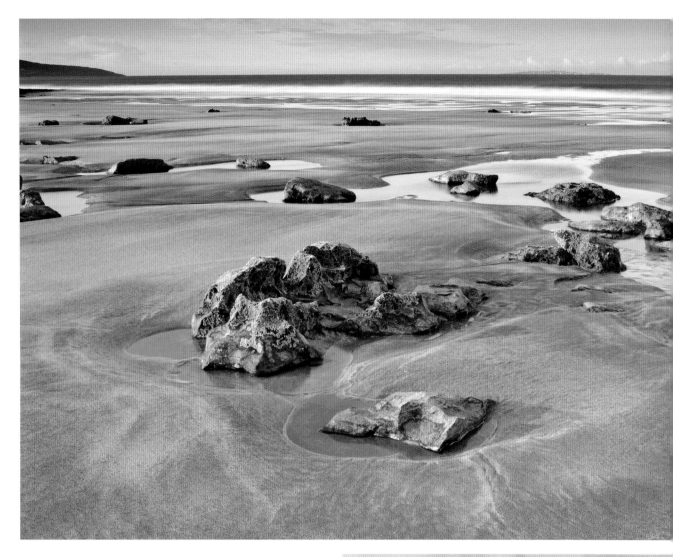

The Cruinniu na mBád is one of many traditional boat festivals that are held in Ireland every year. The star of Cruinniu na mBád, 'the gathering of the boats', is the Galway hooker and to see a whole fleet of them, with their distinctive red sails, is an inspiring sight.

The Galway Hookers are subdivided into four types. The largest vessel, the Bád Mór, or 'large boat', is up to thirteen metres in length. The second largest, the Leath Bhád, or 'half-boat', reaches around ten metres. The other two boats are the small Gleoiteog and the diminutive Púcán. All of them were working boats used to carry all kinds of cargo, but mainly turf and fish, around the Burren and Connemara coast. The bigger boats were able to hold loads of up to fifteen tonnes.

As part of the Cruinniú na mBád festival, a load of turf is delivered to Kinvara by hooker to honour the traditional use of the boat.

Top: Fanore Strand, The Burren, County Clare
Bottom Galway Hookers, Kinvara, County Galway
Opposite: Dunguaire Castle, Kinvara, County Galway

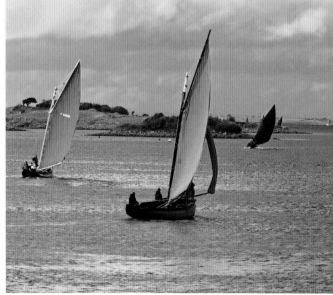

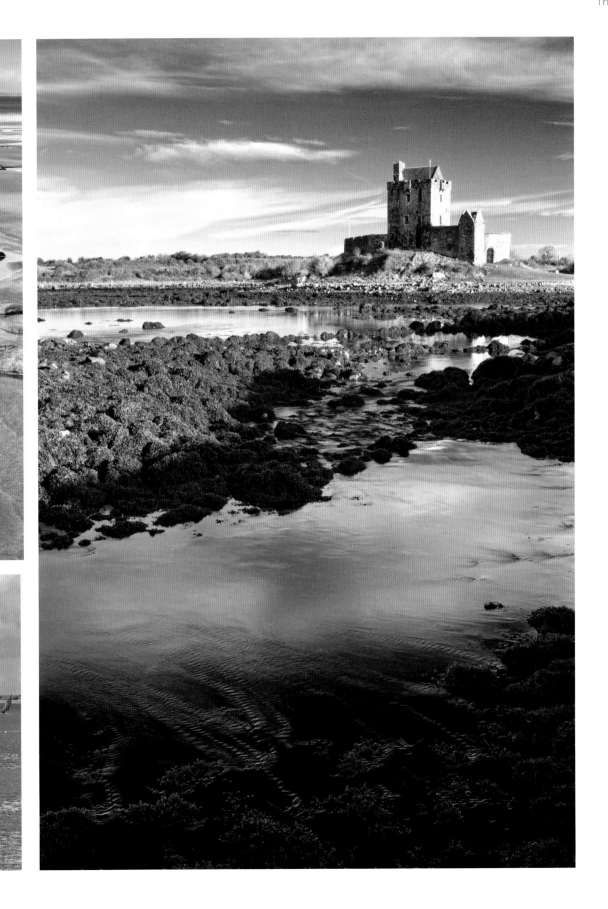

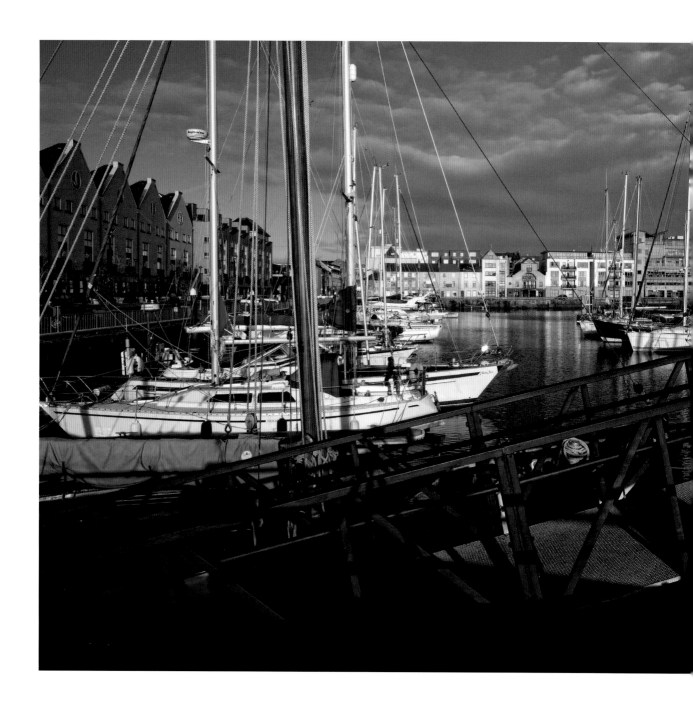

Above: Marina, Galway Docks, County Galway
Opposite: Galway Bay, Connemara, County Galway

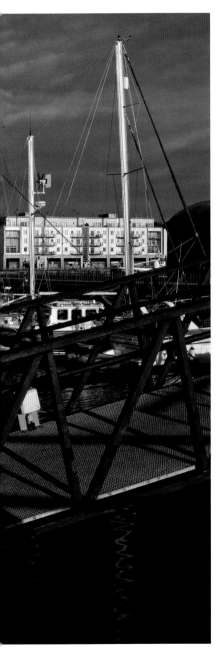

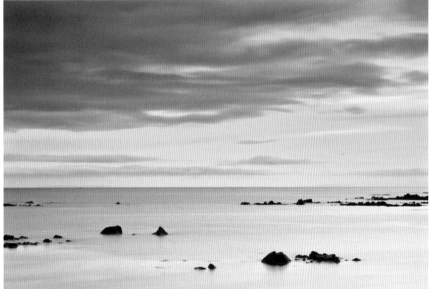

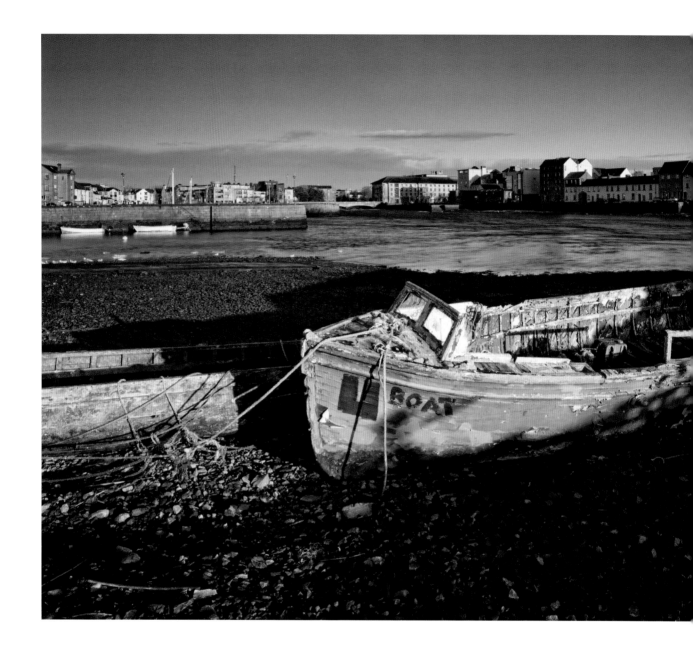

The Claddagh, from the Irish 'cladach' meaning 'stony beach', was once a fishing village at the edges of Galway City. Despite its proximity to the city the Claddagh was a closed community with its own customs, traditions, laws and even its own king.

For centuries the Claddagh fishermen dominated the fishing industry around Galway Bay. The Claddagh community was also one of few that managed to continue their traditional way of life and Irish language and maintain the distinctive look of their village – thatched cottages and cobbled streets – long into the English suppression.

Change however begun in the early 1900s when modern trawlers started to fish in Galway bay. Around the same time living conditions in the village were declared unsafe and cottage after cottage was being knocked down. Over the following decades the face of the Claddagh changed distinctively and today it is firmly integrated into the greater Galway City area. What remain, however, are stories and legends and the famous Claddagh Ring, a distinctive piece of jewellery shaped like two hands joining together to hold a heart topped with a crown; it has been around since the 1700s, but its origins have been lost in time.

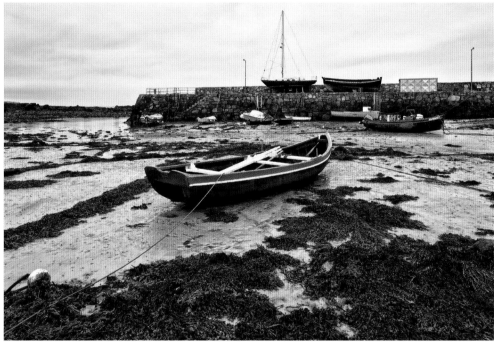

Opposite: The Claddagh, Galway, County Galway
Above: Spiddal, Connemara, County Galway

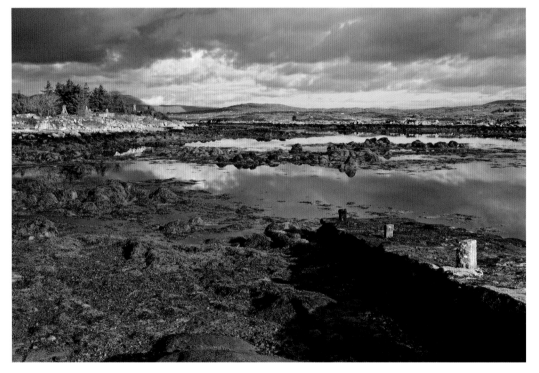

Above: Camus Bay, Connemara, County Galway
Opposite: Culfin Estuary and Mweelrea Mountains, Connemara, County Galway

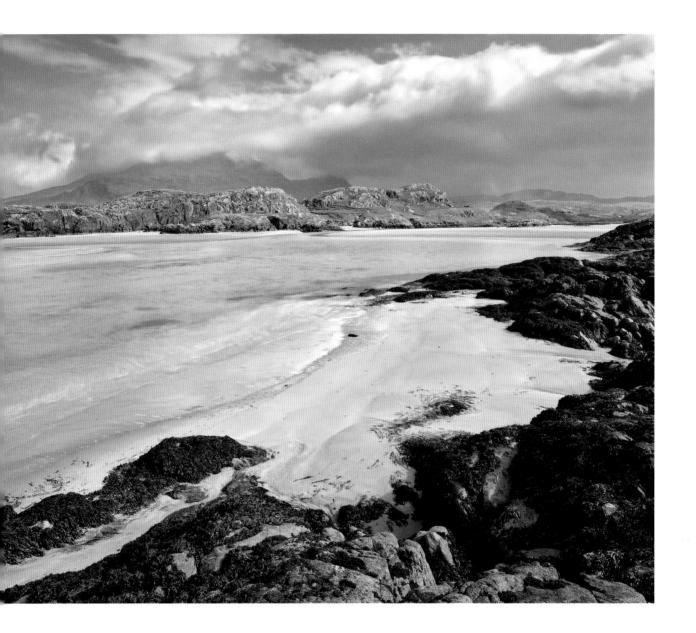

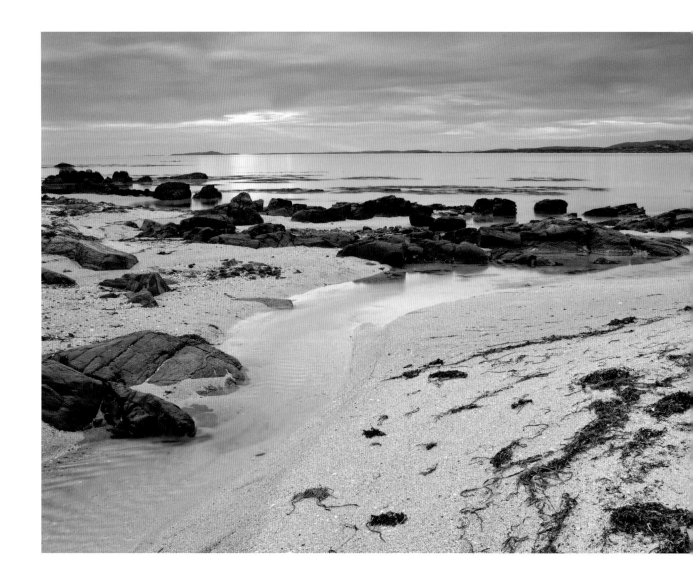

Above: Coral Strand, Mannin Bay, Connemara, County Galway
Opposite: Sand patterns, Connemara, County Galway

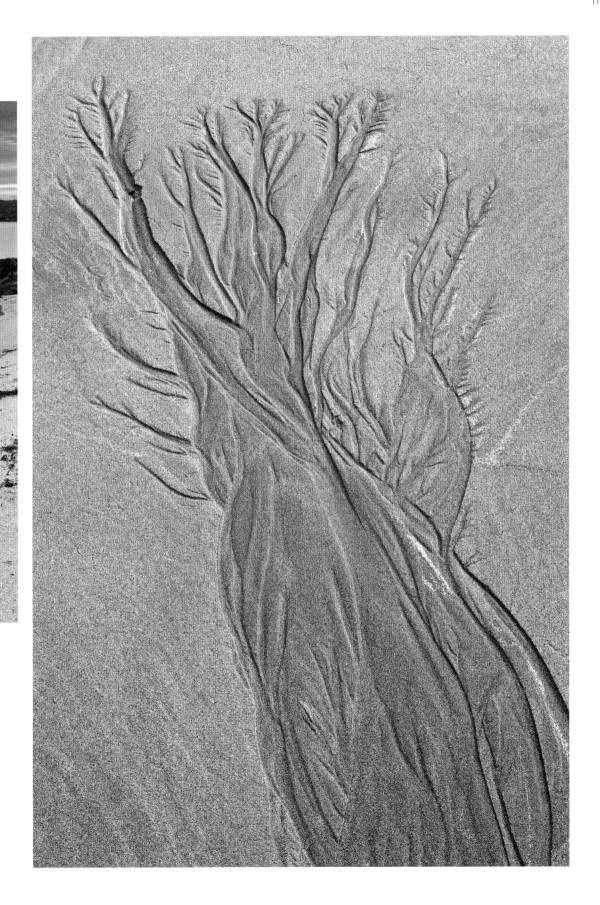

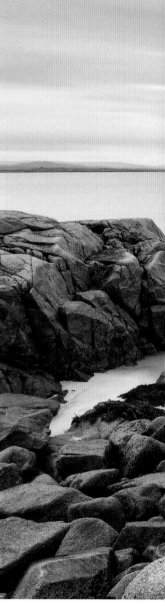

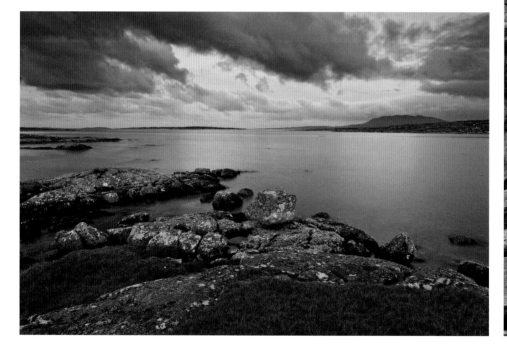

Connemara, and especially its coast, was the first Irish landscape I explored extensively with my camera. During my first year as an Irish resident I was working as a tour guide in Connemara which gave me the chance to get up close and personal with this most unique place. Long summer evenings at Ballyconneely, waiting for the tide to retreat, walking over the vast stretch of sand that connects Omey island with the mainland at low tide and exploring the seaweed covered foreshores around Carna are just a few of many fond memories.

I have returned countless times since then, but so far Connemara hasn't lost its magic. Once this timeless landscape with its sinuous and jagged shores has cast its spell, you will long to return.

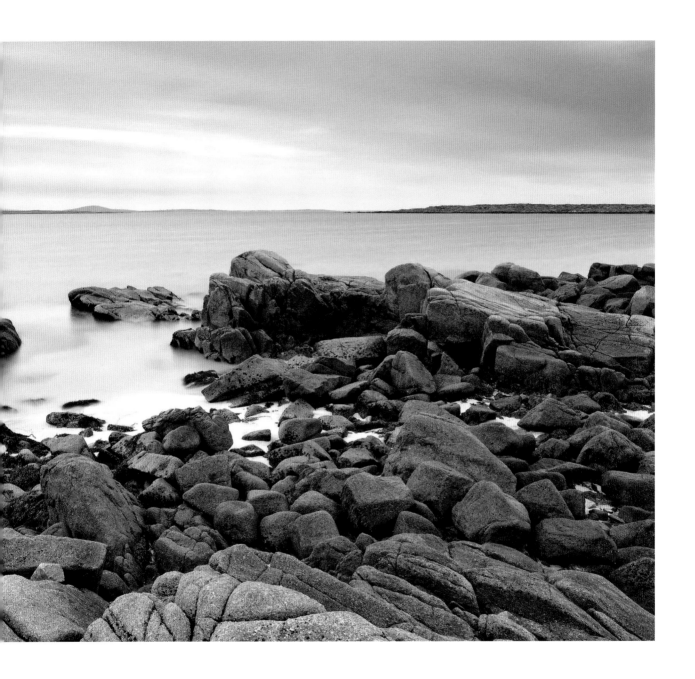

Opposite: Moyrus, Carna, Connemara, County Galway
Above: Gurteen Bay, Roundstone, Connemara, County Galway

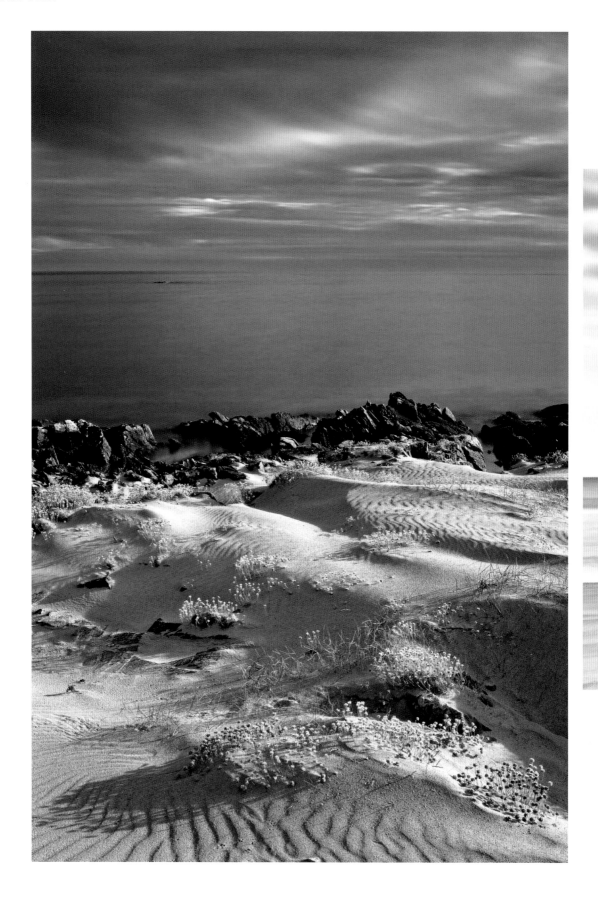

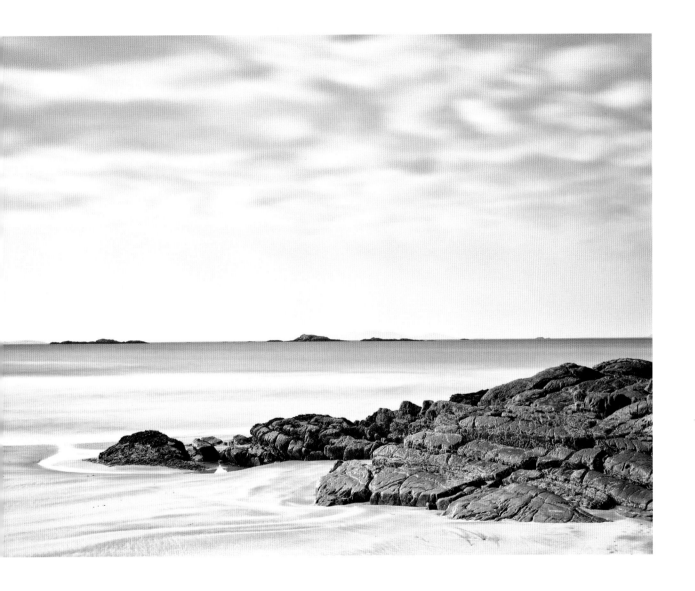

Opposite: Ballyconneely, Connemara, County Galway
Above: Gora Mór, Connemara, County Galway

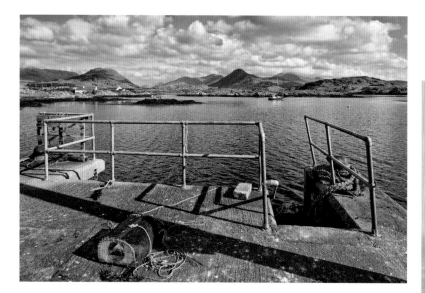

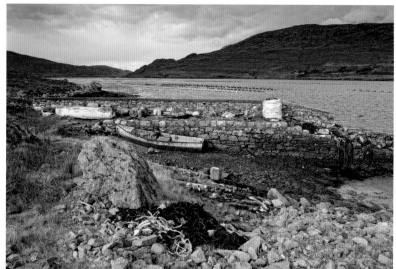

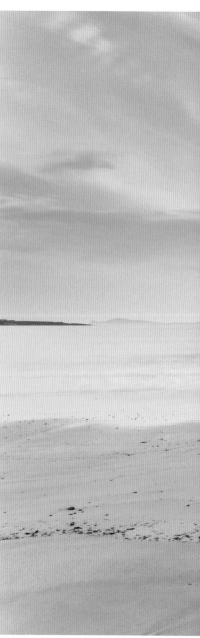

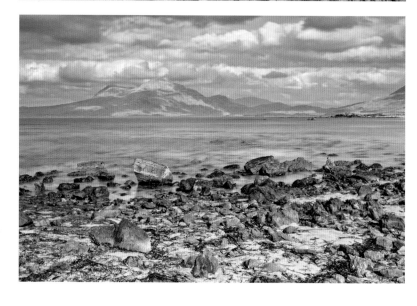

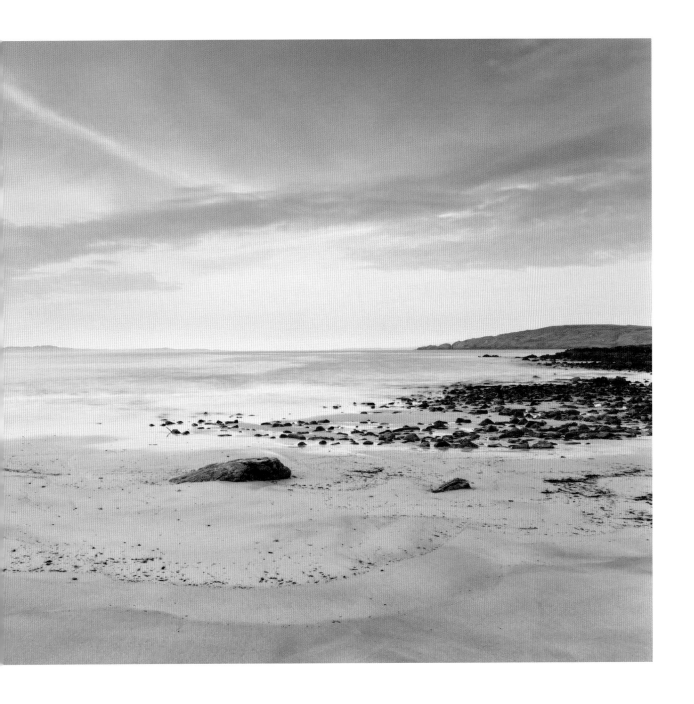

Opposite Top: Derryinver Bay, Connemara, County Galway
Opposite middle: Old pier, Killary, Connemara
Opposite bottom: White Strand, Tully, Connemara, County Galway
Above: Sellerna Bay, Connemara, County Galway

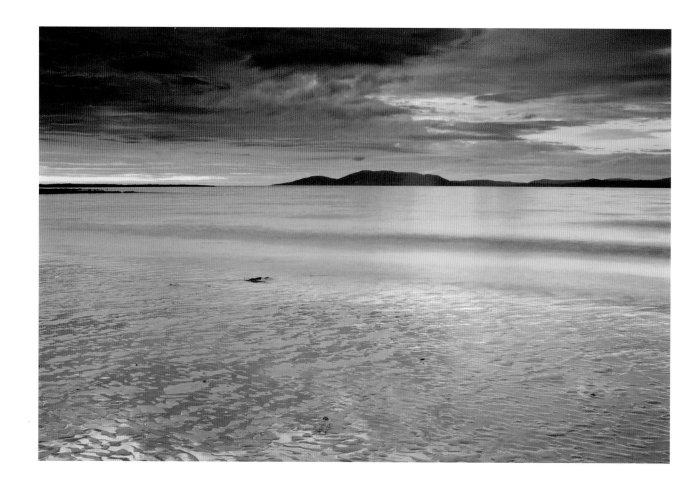

Above: Burning Sky, Streedagh Strand, County Sligo

THE NORTH WEST

The counties Mayo, Sligo, Leitrim and Donegal form the northwestern coast of Ireland. This is probably the wildest and most dramatic part of the coast, battered by gales and storms more often than the rest of the country; in December 2011 a 20.4 metre-high wave was recorded off the Donegal coast, at the time the highest ever recorded.

For me, the northwest begins just north of Killary Harbour and the Mweelrea Mountains. A string of seemingly endless sandy beaches runs up to Carrickvegraly Point where the coastline makes a sharp turn east and opens up into Clew Bay. According to legend the wide bay is dotted with 365 islands, one for each day of the year. These islands are sunken drumlins, small hills that were formed by retreating glaciers, and in reality there are only around 117 of them. The northern entry to the bay is guarded by the Curaun peninsula and Ireland's biggest and probably most famous island: Achill. Overlooking Clew Bay is Croagh Patrick, locally known as 'the Reek', Ireland's holy mountain. According to legend, St Patrick fasted there for forty days in the fifth century. Today every last Sunday of July several thousand pilgrims climb the Reek, rain or shine.

North of Achill the coast is rugged, wandering inland to form bays or to follow river estuaries. At Benwee Head, one of the most breathtaking headlands the coast turns east once again. Beyond that lies mile after mile of head-spinning cliffs that only run out at Killala Bay. This funnel-shaped bay became famous as landing place for the French, who came to help the Irish with their fight for independence from British rule during the 1798 rebellion.

Left to right: Common Sea Urchin. Bloody Henry starfish

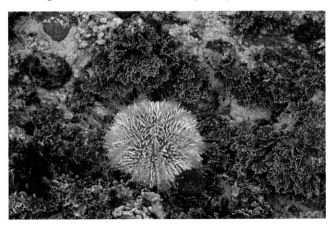
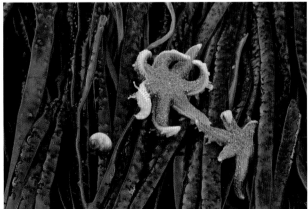

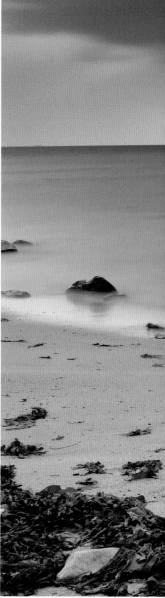

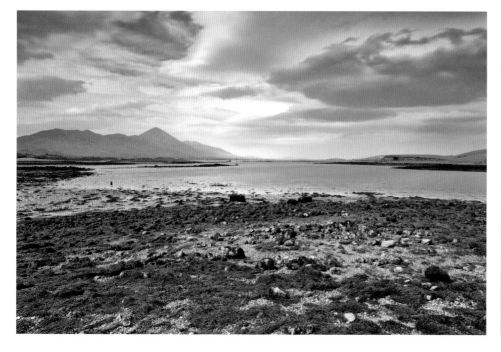

Further east lies Sligo Bay, overlooked by the enigmatic shapes of Sligo's mountains and resting place of W. B. Yeats one of Ireland's most famous poets. Here the coast runs northward again, with rocky shores and some of Ireland's best-known surfing beaches like Bundoran, until it reaches Donegal Bay.

The Donegal coastline is home to some of the most remote and rugged places in Ireland. The hump of the Slieve League Peninsula with its spellbinding cliffs is followed by river estuaries, bays, inlets and clusters of islands, which are the main features of Donegal's west coast. This area is Ireland's biggest Gaeltacht (Irish-speaking) area.

North Donegal is dominated by sea loughs that penetrate far inland: Mulroy Bay, Lough Swilly and Lough Foyle. In-between are windswept headlands like Melmore Head, Fanad Head and – laying claim to the title of mainland Ireland's most northerly point – Malin Head. Geographically, however, this title belongs to Banba's Crown northeast of Malin Head. Ireland's true north is Inishtrahull Island and even further north are the Torr Rocks at 55° 27' 03" North.

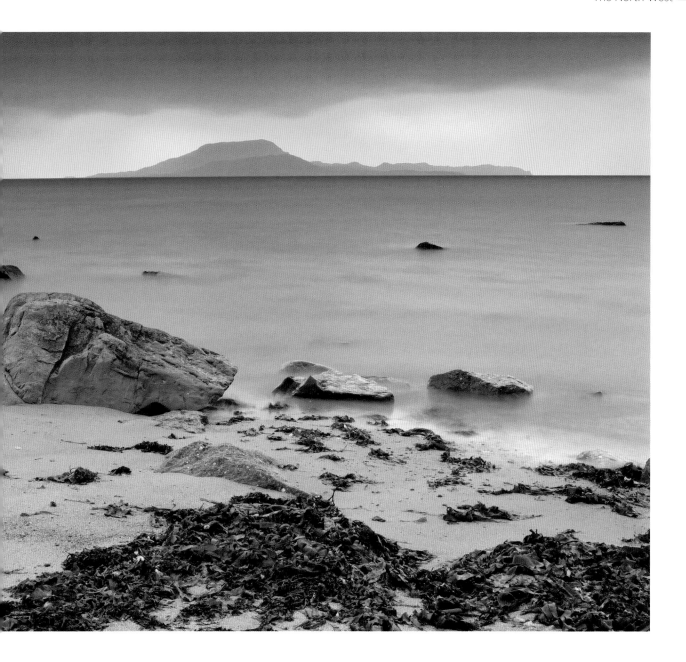

Opposite page: Clew Bay and Croagh Patrick, County Mayo
Above: Clare Island from Bunowen Strand, County Mayo

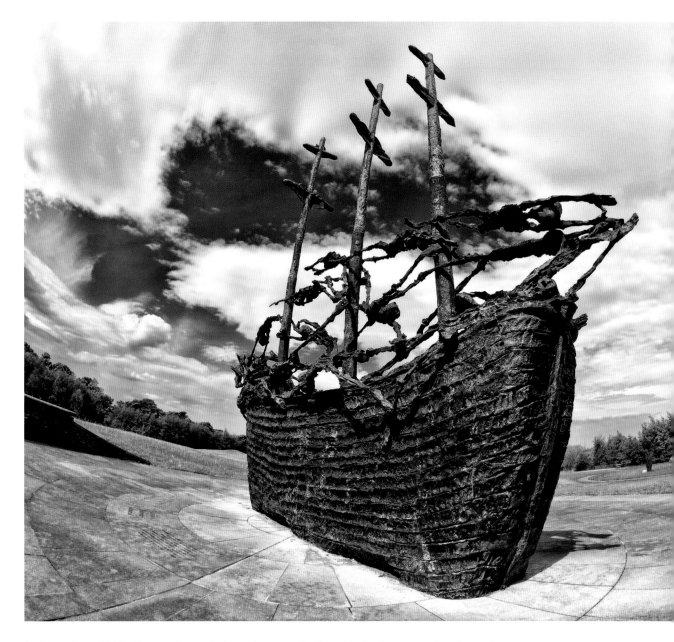

'An Gorta Mór' – 'the great hunger' – better known as the Great Famine is an event that changed and defined Ireland; in the years between 1845 and 1852 it's estimated that a million people starved to death and another million or more emigrated, reducing the Irish population by around a quarter.

Those who were able to leave crossed the Atlantic Ocean to seek a better life in the USA or Canada on what became known as Famine Ships or Coffin Ships. Conditions on these ships were anything but good:

'*Hundreds of poor people, men, women and children of all ages huddled together without light, without air, wallowing in filth and breathing a fetid atmosphere, sick in body, dispirited in heart; the fevered patients lying beside the sound, by their agonised ravings disturbing those around ...*'

(Stephen de Vere, who sailed to America in steerage in 1847).

Almost half of the people heading for the New World lost their life on the journey.

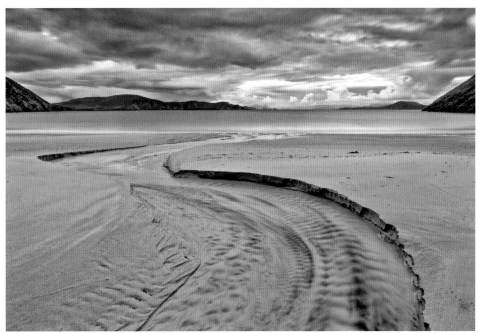

Opposite: Famine Memorial, Murrisk, County Mayo
Above: Keem Strand, Achill Island, County Mayo

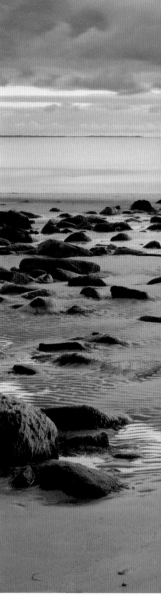

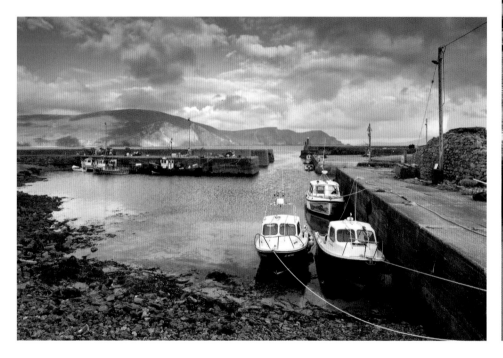

Achill is Ireland's largest off-shore island and has been and still is a favorite with artists, including photographers, for centuries. The British novelist Graham Greene wrote parts of his novel *The Heart of the Matter* and *The Fallen Idol* in the village of Dooagh. The German author and Nobel Prize winner Heinrich Böll was a regular visitor to Achill in the 1950s and 1960s and he documented his visits in what became one of his best loved books *Irisches Tagebuch / Irish Journal*. Böll's cottage is now a retreat for artists and writers. One of America's foremost painters, Paul Henri, also owned a house on Achill where he painted mainly portraits of local people and Ulster-born painter Paul Henry lived and worked on Achill for a decade where, it is said, he first found his inspiration for his famous West of Ireland landscape paintings.

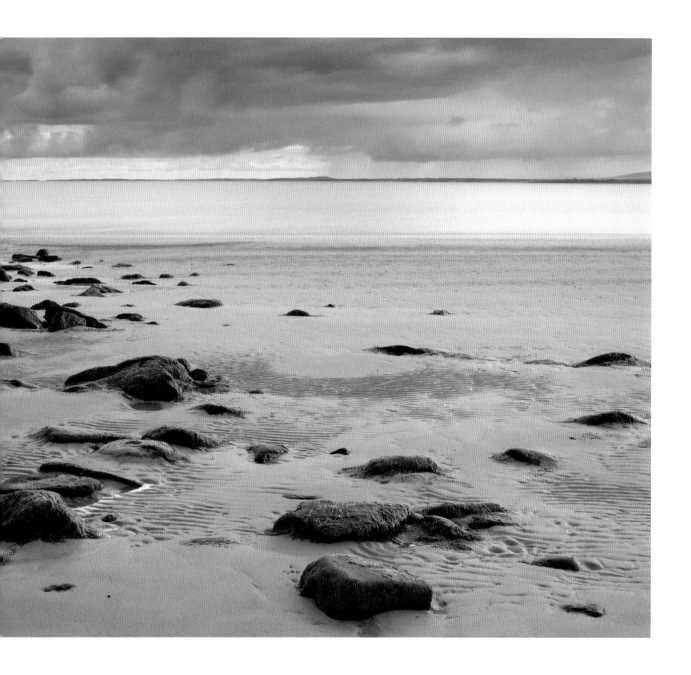

Opposite: Pollagh Harbour, Achill Island, County Mayo
Above: Barnynagappul Strand, Achill Island, County Mayo

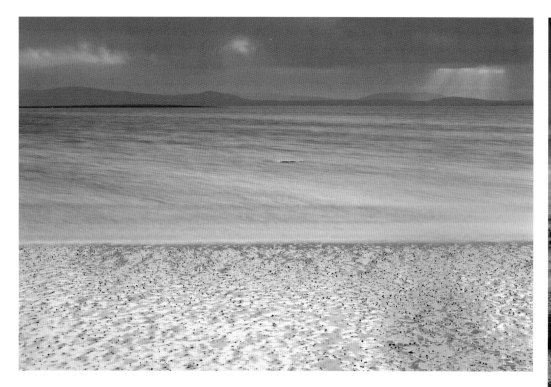

The Mullet Peninsula, also known as The Mullet, is a long and narrow promontory that is connected to the mainland only by a small isthmus at its northern end. The Mullet's southern part is a flat and windswept place with wide sandy beaches and rocky shores. In the North the landscape rises up to form the exposed cliffs of Erris Head that allow dramatic views over the North Mayo landscape. On my visits the weather came with cloud, wind and showers, the kind of weather that seems tailor-made for this beautiful and sad landscape.

This is how the Mullet looks today and judging by the description the Irish naturalist Robert Lloyd Praeger gave in the early 1900s nothing much has changed since then:

'Belmullet lies on an absurdly narrow isthmus which separates Broad Haven on the North from the much larger and deeper bay of Blacksod on the South, and almost makes an island of the Mullet. Blacksod Bay has low and rather desolate shores on either side, but Broad Haven, though more sterile, is more attractive, as the Atlantic waves, beating into it, have carved a boulder coastline, which outside the bay becomes very grand … The Mullet, that remote peninsula, half bog, half sand, full of bays and queer lakes and outlying islets; tree-less, sodden, storm swept, and everywhere pounded by the besieging sea, beautiful on a fine day, with wondrous colour over land and ocean, desolate beyond words when the Atlantic rain drives across the shelterless surface.'

(from *The Way That I Went* by Robert Lloyd Praeger 1865-1953)

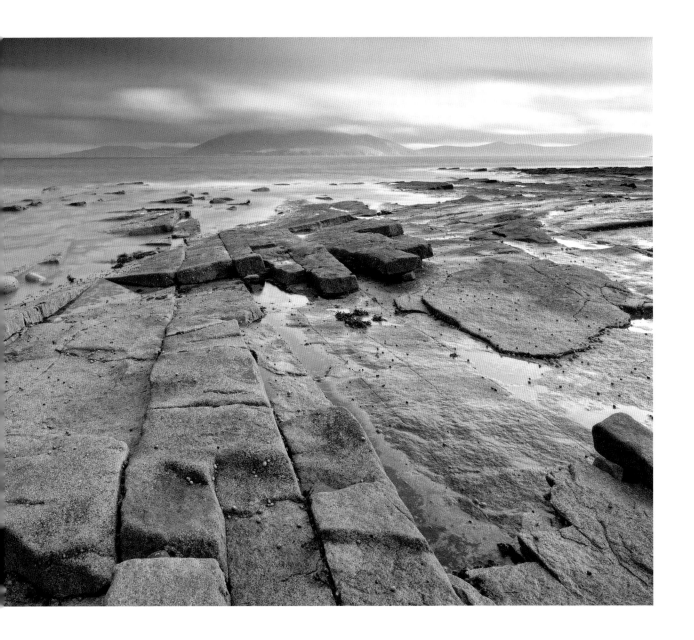

Opposite: Elly Bay, Mullet Peninsula, County Mayo
Above: Blacksod Bay, Mullet Peninsula, County Mayo

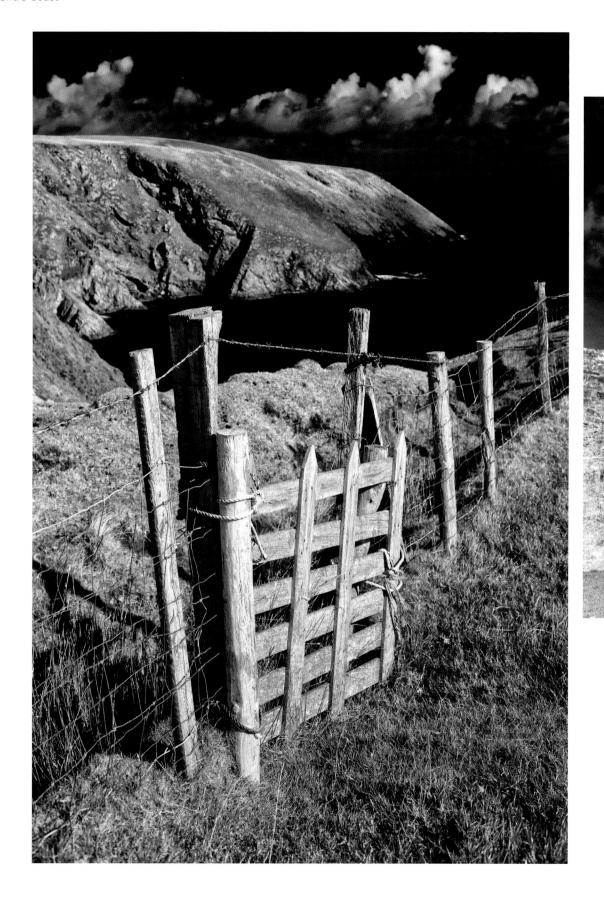

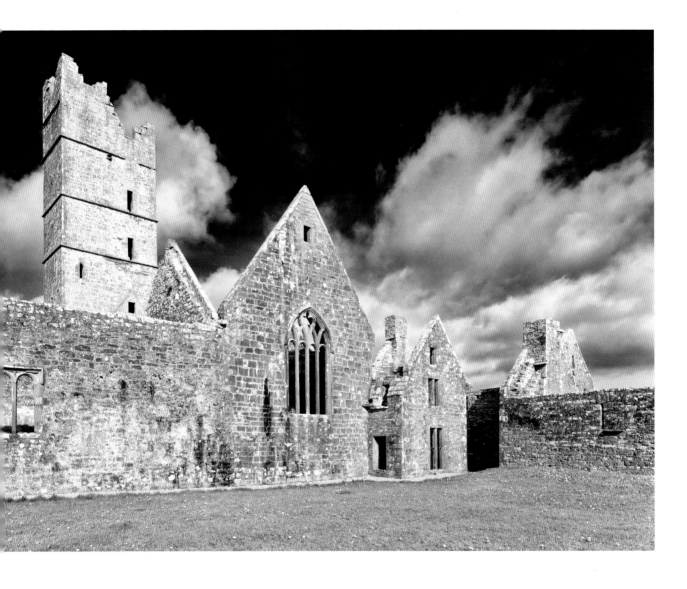

M oyne Abbey is one of Ireland's best-preserved monasteries and the fact that the monastic grounds are overlooking Killala Bay gave me a welcome excuse to include this amazing place in this book.

The abbey was founded by permission of Pope Nicholas for the Observantine Franciscans around 1460 and consists of several buildings including a sacristy, a chapter house, kitchen and refectory and an almost intact tower.

In its heyday Moyne Abbey was home to around fifty monks. After several raids in the late 1500s, during which parts of the friary were burned down, the community dispersed. Over the succeeding centuries only a handful of monks kept the friary alive and it is thought that the last friar of Moyne, Fr Thomas Burke, died in 1800.

Opposite: Gateway, Erris Head, County Mayo
Above: Moyne Abbey, Killala Bay, County Mayo

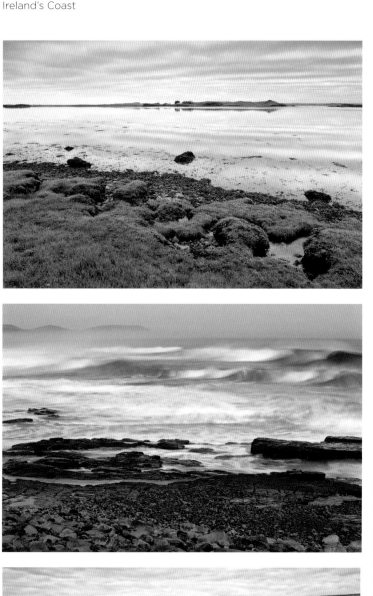

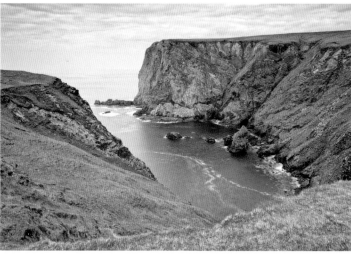

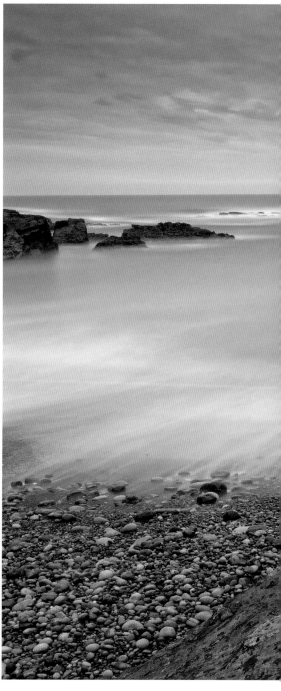

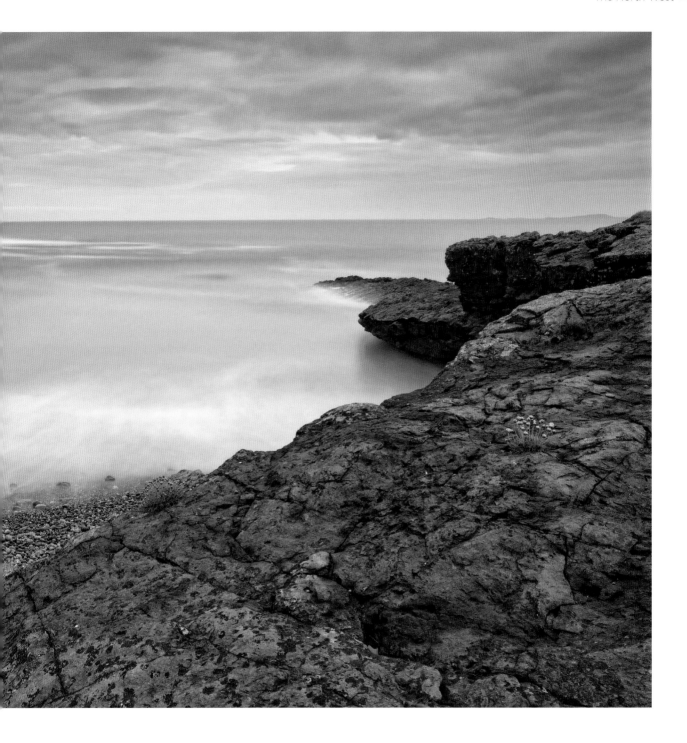

Opposite from top: Soft morning, Killala Bay, County Mayo
Stormy Weather, Downpatrick Head, County Mayo
Benwee Head, County Mayo
Above: Aughris Head, County Sligo

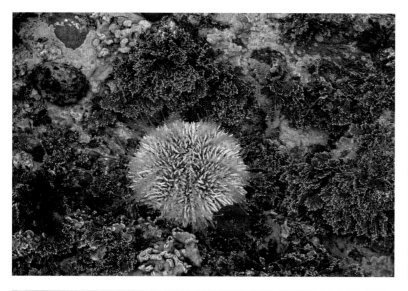

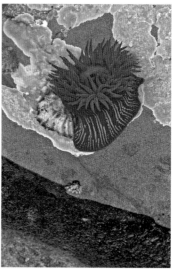

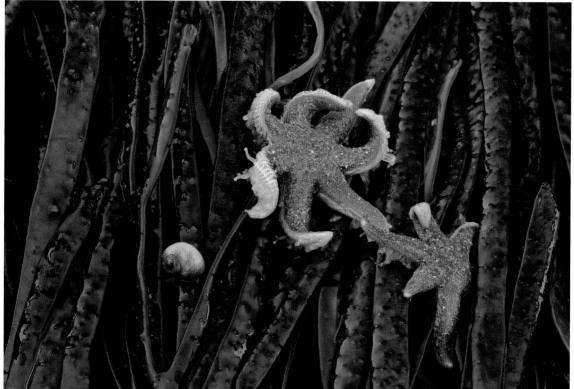

R ock pools, or tidal pools, are a colourful microcosmos of marine life and can be found on many rocky shores all around the Irish coast with some of the finest examples along the shores of the west and northwest. Twice a day the retreating tide leaves behind not only exposed rock surfaces, but also water-filled crevices, hollows and pools.

These sanctuaries are home to mussels, crabs, starfish, urchins, shrimps, fish and countless other fauna and flora. These plants and animals are among the hardiest on the planet. They have to endure extreme fluctuations in water temperature, salinity and oxygen levels. Huge waves, strong currents and the exposure to predators and 'rock-pooling' homo sapiens, including eager photographers, are just a few of the hazards they have to cope with on a daily basis.

Top left: Common Sea Urchin
Top right: Beadlet Anemone
Bottom: Seven Armed Starfish

Opposite top: Bloody Henry
Opposite bottom left: Common Starfish
Opposite bottom right: Spiny Starfish

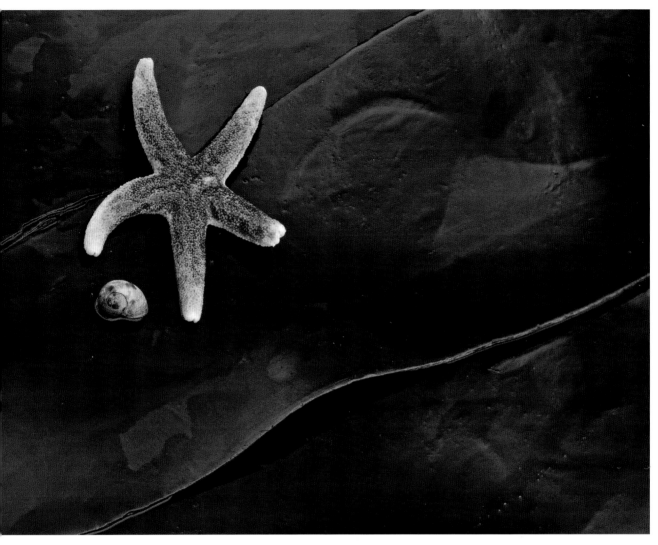

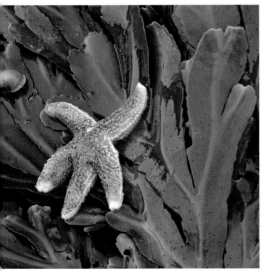

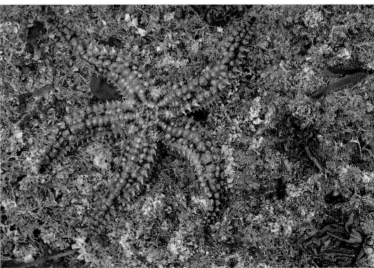

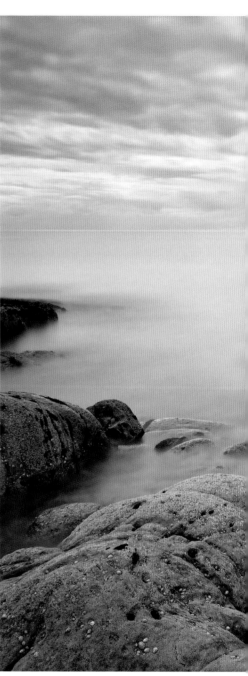

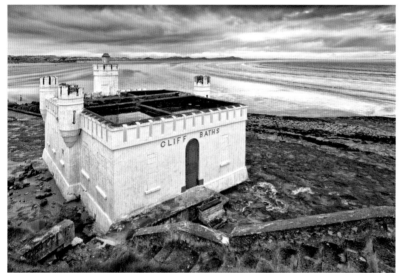

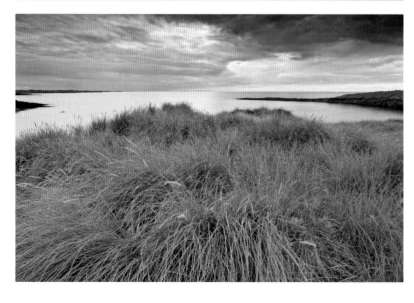

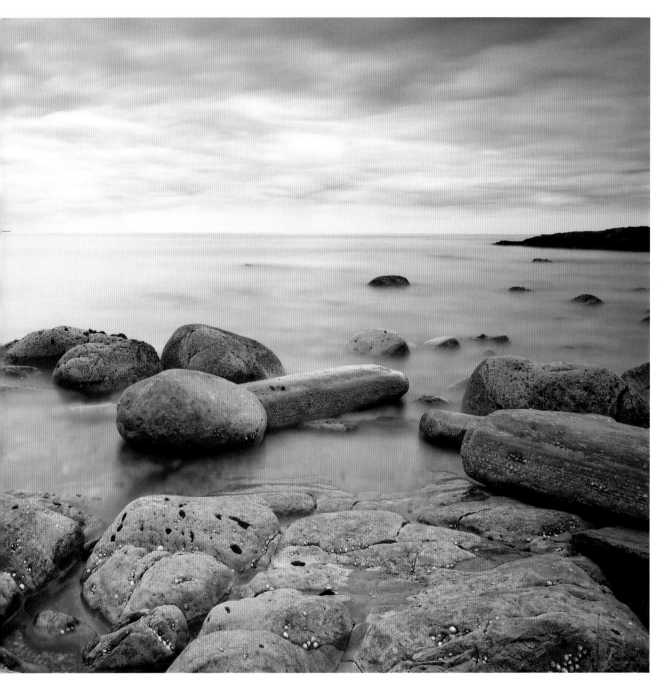

Enniscrone is one of Ireland's major seaside resorts built around a wide sandy beach with adjoining dunes and indispensable golf course. Resorts like Enniscrone developed during the Victorian era to cater for the holiday needs of the upper class and the rich. The old cliff bath, built in 1850 in typical Victorian style, is an elegant reminder of this era.

Today towns like Bray, Tramore, Kilkee or Ballycastle, to name but a few others, attract visitors from abroad and Irish tourists alike and offer a multitude of amenities. Unfortunately all of these towns suffer one common fate: The big hustle and bustle of the summer months disappears rather suddenly in early autumn and most resorts become ghost towns for the winter months.

Opposite top: Mullaghmore Harbour, County Sligo
Opposite middle: Enniscrone Cliff Baths and Strand, County Sligo
Opposite bottom: Trawgar, Streedagh, County Sligo
Above: Illaunee Beg, Mullaghmore, County Sligo

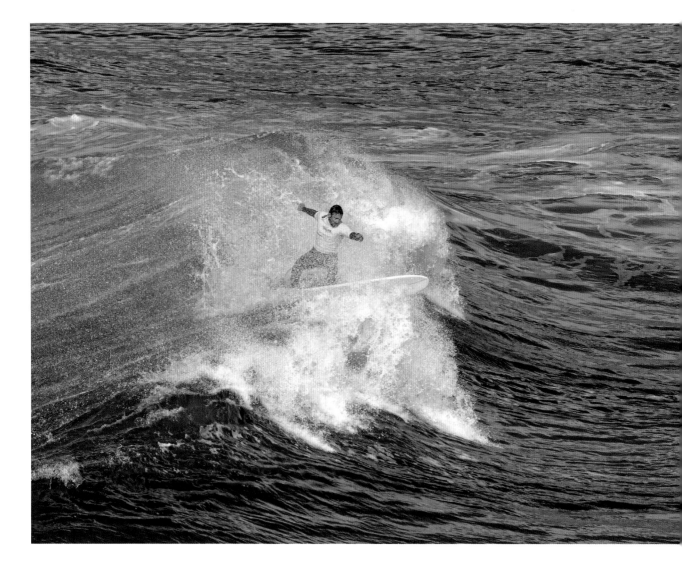

The origins of surfing can be found somewhere in the Pacific Ocean some three thousand years ago. Many archeologists believe that ancient Peru is the cradle of surfing; pottery found there shows people riding on waves on what very much resemble surfboards. These devices that are thought to have been halfway between a boat and a surfboard, called *Caballito de Totora*, were most likely made out of buoyant reeds.

The first Europeans to witness surfing were the crew of the HMS *Endeavour* under captain James Cook in 1769 when they landed on Polynesia. For many Polynesian cultures the art of surfing was much more than just a recreational sport – it was a part of their heritage and spiritual beliefs. Priests were integral part of the ritual, blessing new boards and praying to the gods for good surf.

James Cook and his men were followed soon after by western missionaries who suppressed surfing and other local traditions for many decades. The art of surfing almost became forgotten.

In the early twentieth century, however, surfing was rediscovered by Westerners almost simultaneously in America and Australia. Subsequently it also saw a revival in its native Hawaii. The rest is, as they say, history.

The very first Irish surfer was probably Joe Roddy, son of a lighthouse keeper on Ireland's east coast, who rode the waves off Dundalk on a self-made board sometime around 1949.

Kevin Cavey and Ian Hill however were the ones who firmly established an Irish surf scene in the 1960s and today Ireland is one of the surf capitals of the world. It is said that Irish beaches like Inch Strand, Lahinch, Keel or Bundoran, have the best surf outside Hawaii. In 2011 the European Championships came to Ireland for the first time and were held in Bundoran.

Opposite: Incoming tide, Bundoran, County Donegal
Above: Bundoran Surfer, County Donegal

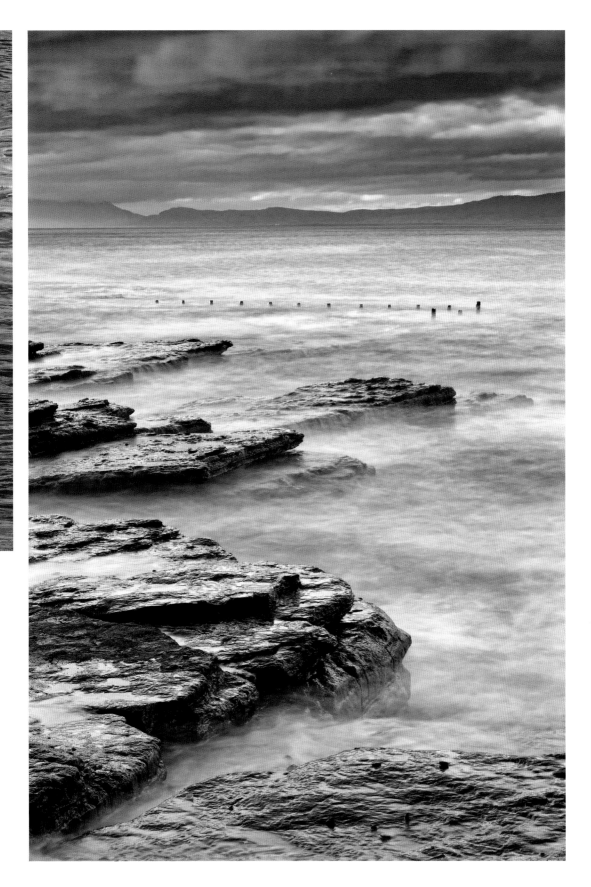

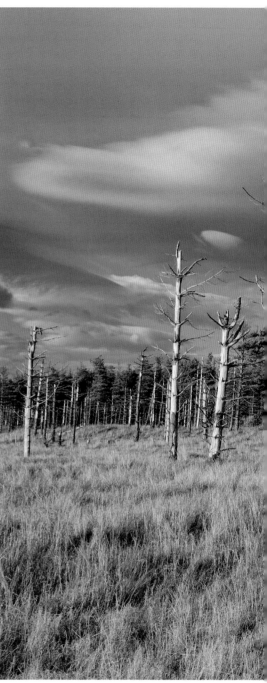

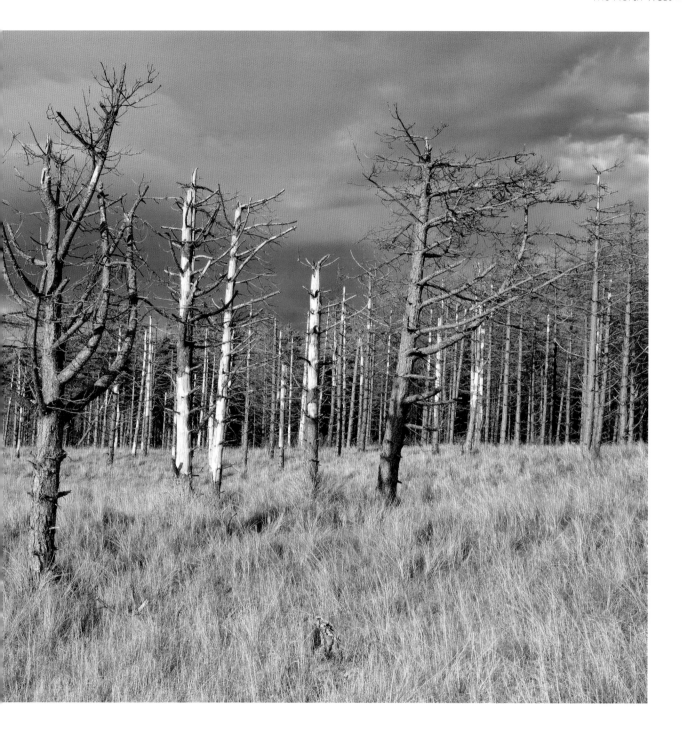

Left page top: Thrift & Lichen, County Donegal
Left page bottom: Dune Flora, County Donegal
Above: Murvagh Forest, County Donegal

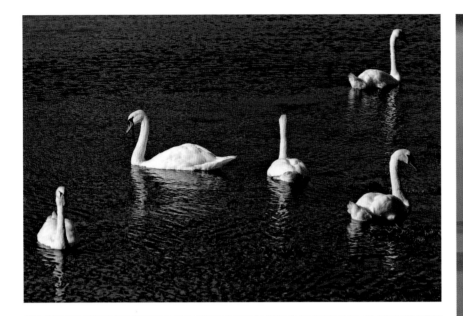

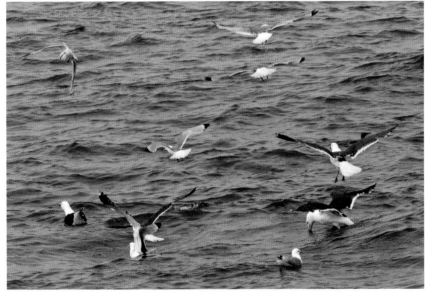

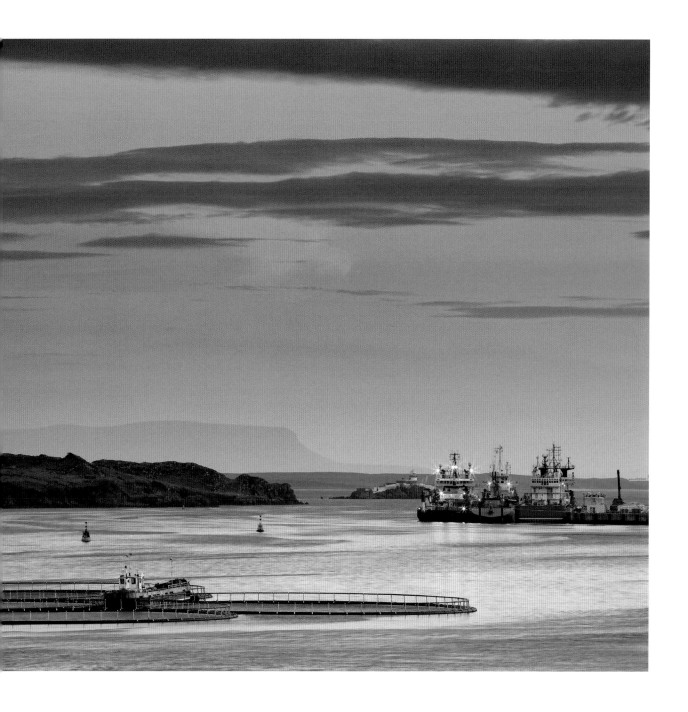

Above: Killybegs Harbour, County Donegal
Opposite top: Mute Swans, Clew Bay, County Mayo
Opposite bottom: Black Backed and Herring Gulls, feeding frenzy, County Donegal

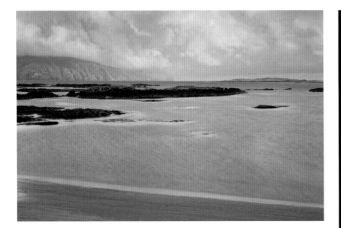

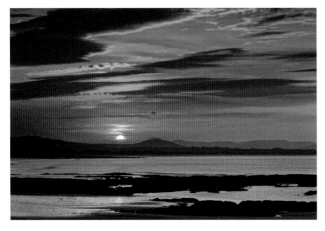

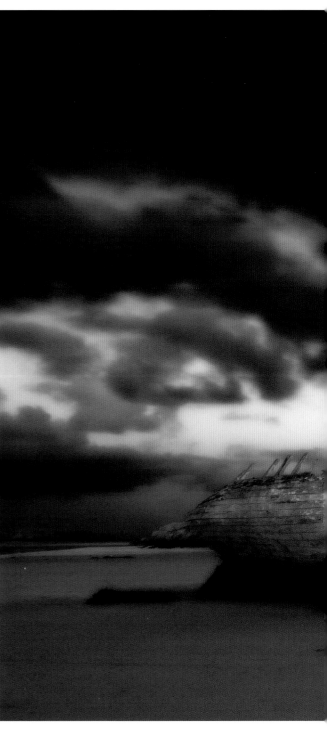

Top: Loughros More Bay, County Donegal
Middle: Maghera Caves, County Donegal
Bottom: Sunset, Fanad, County Donegal
Opposite: Eddie's Boat, Bunbeg, County Donegal

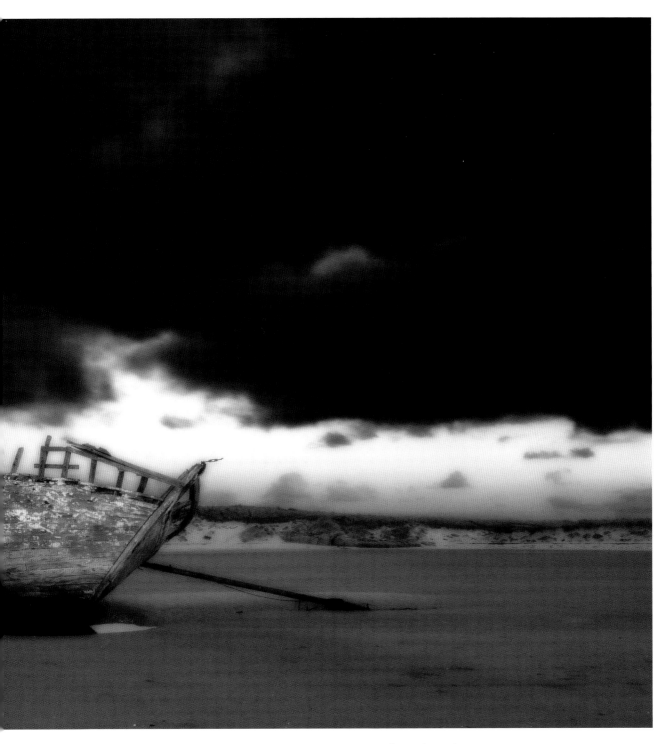

The caves at Maghera Beach have been formed by the relentless power of the tides and are surrounded by many tales and mysteries. One time it is said a man and his dog entered the caves. Sometime later the dog emerged several miles away at Glencolmcille, the man however has never been seen again. Another story tells us about five hundred or so Irish rebels and their families hiding in the caves. To mark the birth of a child a candle was placed in one of the cave entrances. This light was seen across the bay and alarmed the occupying English forces. It is said that all but one man were slaughtered that night.

In the early 1970s the *Bád Eddie*, 'Eddie's Boat', ran aground at the sheltered bay of Magherclogher where it has become one of Ireland's most photographed shipwrecks and has become a Bunbeg landmark.

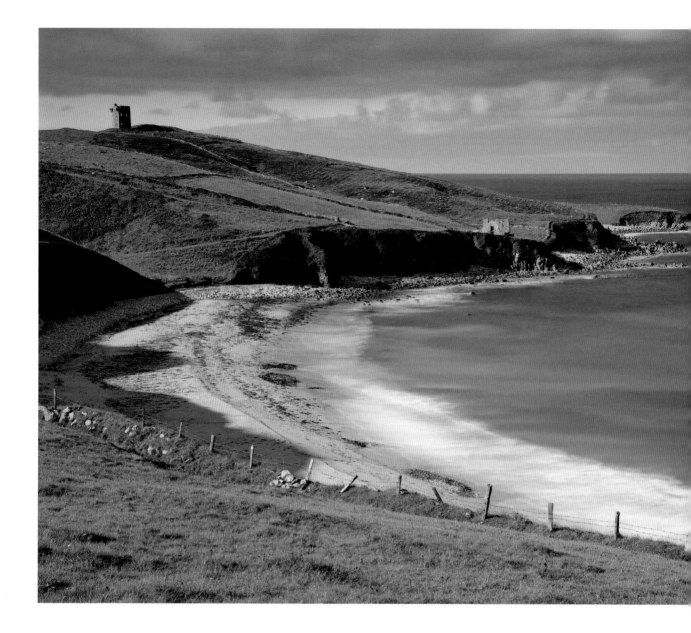

Slieve League reaches a height of six hundred metres and is among the highest sea cliffs in Europe. Getting there is an adventure in itself. A few kilometers west of Killybegs the traveler enters a net of small country roads that wind southwards along Teelin Bay and then turn west into and over the mountains. The last stretch of road twists and turns in a steep up and down fashion along a narrow ridge. The road is hardly wide enough for one car and there is nowhere to pull in. I expected to take a tumble into the abyss beside the road any moment and prayed that there might be no oncoming traffic.

Slieve League itself almost defies description. It is literally land's end. There is mountain and sea and nothing more. Its remoteness, majesty and beauty make Slieve League an extraordinary place. If there only wasn't the way back along that road.

In 1812 the frigate *Saldana* was wrecked at the treacherous rocks of Fanad Head, which was known as Fannett Point back then, leaving a parrot as the only survivor. This tragedy resulted in the decision to built a lighthouse and Fanad Lighthouse was subsequently lit for the first time on 17 March 1817. Dramatically situated on a rocky outcrop, Fanad Lighthouse watches over both the Fanad headland and the entrance to Lough Swilly.

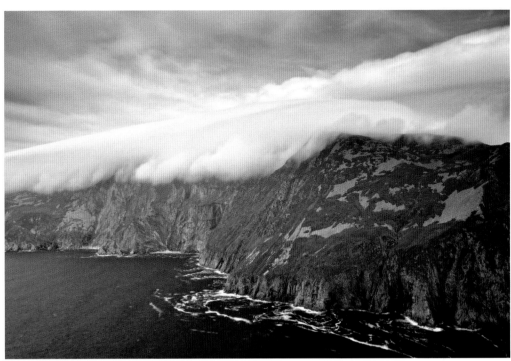

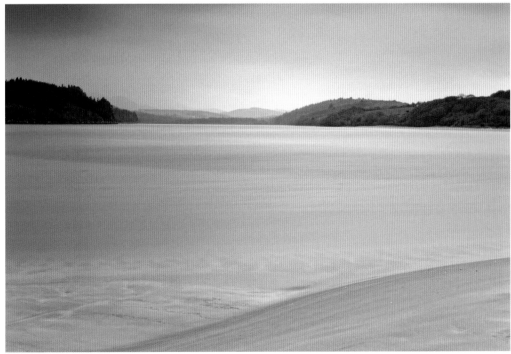

Top: Slieve League, County Donegal
Bottom: Jeffrey's Lough, Ards Forest, County Donegal
Opposite: Crohy Head, County Donegal

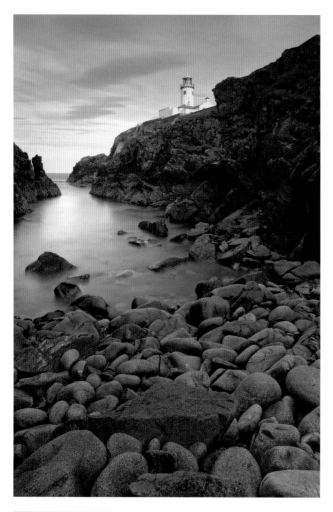

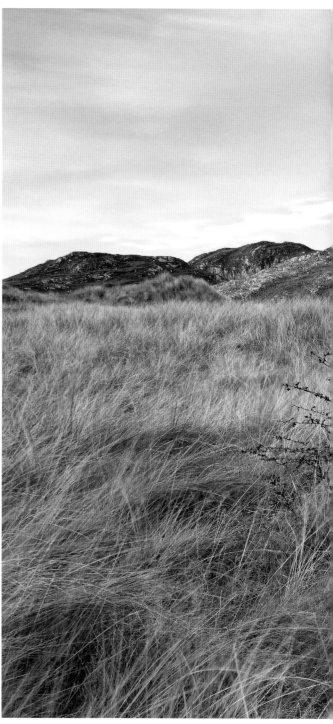

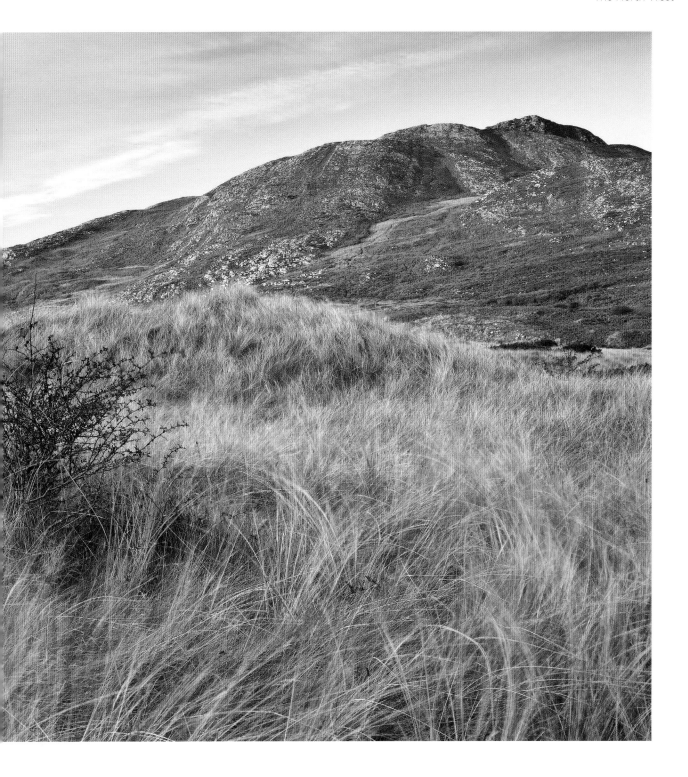

Opposite top: Fanad Head Lighthouse, County Donegal
Opposite bottom: Fog on Lough Swilly, Inishowen Peninsula, County Donegal
Above: Urris Hills and dunes, Inishowen Peninsula, County Donegal

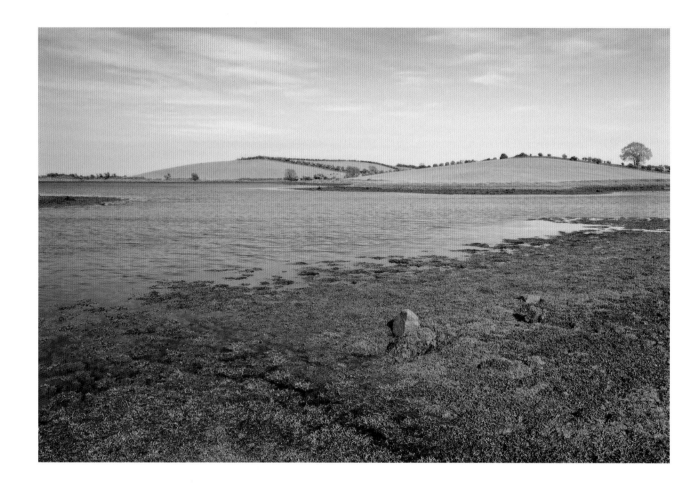

Above: Drumlins at Strangford lough, County Down

THE NORTH EAST

The north eastern corner of Ireland boasts two very different, but equally breathtaking landscapes – the jaw-dropping drama of the Antrim coast and the softer, more rounded landscape of the Strangford Lough area.

The Antrim coast looks like something from the epic novels of J.R.R. Tolkien and C.S. Lewis, which is perhaps unsurprising when one realises that Lewis was born in Belfast and spent his childhood summers on the north east coast. Rugged cliffs, rock arches and sea stacks intertwine with wide, sandy beaches and boulder-strewn bays. The whole area is sprinkled with historic castles and monasteries. It is not surprising that the Causeway Coastal Route, which runs from Portrush to Carrickfergus, can regularly be found among the world's top scenic drives. The mysterious Dunluce Castle and the wide sandy beach of Whitepark Bay can all be found along this route.

As can the Giant's Causeway, probably the most famous part of the Antrim coast. This natural causeway is made of an estimated 40,000 hexagonal basalt columns stretching out into the ocean and was formed during a long period of volcanic activity some sixty million years ago. That is if you believe the scientists.

Legend tells us a more colourful theory and attributes the causeway to the giantFinn McCool. Finn had a mortal enemy in Benandonnar, a giant living on the Scottish island of Staffa. Both giants decided to build a road across the ocean, Finn starting in Antrim, Benandonnar starting on Staffa.

The two giants eventually met in the middle, but the resulting fight unfortunately destroyed most of their handiwork. All that remains today is the Giant's Causeway in Antrim and a smaller causeway at Fingal's Cave on Staffa.

However, the best sights as far as I am concerned, are slightly off the main track. Fair Head seen from Murlough Bay is probably my favourite view in Ireland and manages to amaze me every time I return.

This also goes for Rathlin Island, which lies a short boat trip off the Antrim coast. Like all of Antrim this island is full of history and legends. Robert the Bruce supposedly had his life changing encounter with a spider in a cave on Rathlin. Legend tells us that Robert the Bruce was on the run, his army scattered after having lost six battles against the English invaders. Robert eventually fled to Rathlin where he hid in a cave and contemplated his fate. One rainy day he was watching a spider weave her web. He watched her working slowly and with care, trying to throw her thread from one end of the cave to the other. Six times she tried, six times she failed. 'Poor creature,' said Robert the Bruce, 'you too know how it feels to fail six times in a row.' The spider, however, didn't give up and her seventh attempt was successful. It is said that the little spider's determination inspired him not to give up. He gathered his forces again and eventually Scotland became independent and Robert the Bruce king of Scotland.

Strangford Lough to the south of Antrim couldn't be visually more different. This sea lough, formed by retreating glaciers some ten thousand years ago, is a soft and understated affair. The landscape of Strangford is dominated by drumlins – distinctive round hills made of glacial deposits – muddy shores and scattered islands.

The lough stretches from the wide, calm mudflats of the north for thirty-two kilometres to the so called 'Narrows' in the south. Here the Irish Sea enters and leaves Strangford Lough with powerful tidal currents, carrying about 350 million cubic metres of water with every tide. Early Viking invaders called the place '*Strangfjörthr*', 'the strong fjord'.

Strangford Lough is one of the most peaceful and calming places I know and spending a summer afternoon at Reagh Island, watching the tide come and go, is one of my most treasured memories.

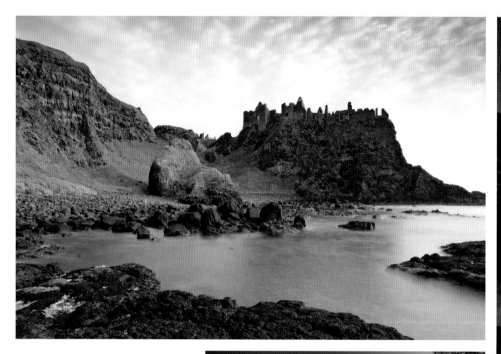

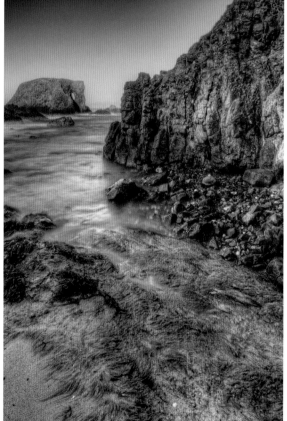

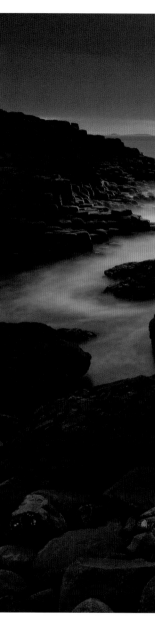

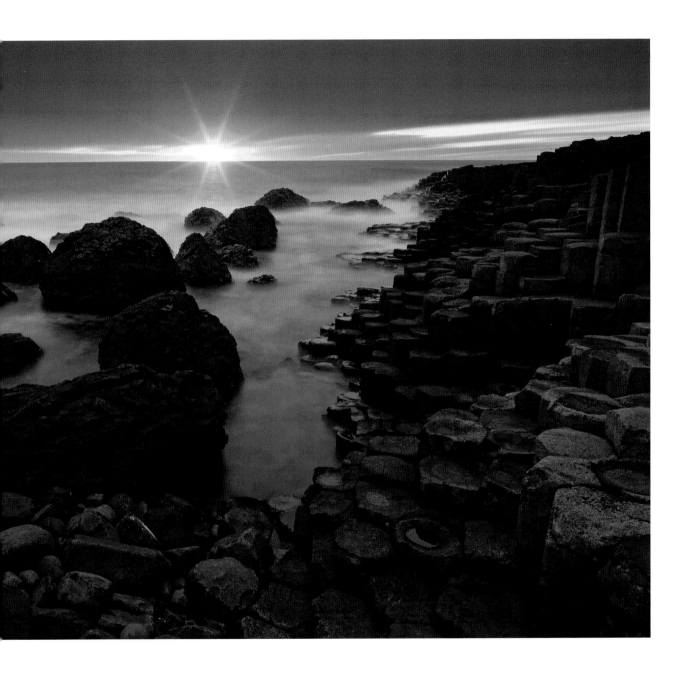

Left page top: Dunluce Castle, County Antrim
Left page bottom: Elephant Rock, Ballintoy, County Antrim
Right page: Giant's Causeway, County Antrim

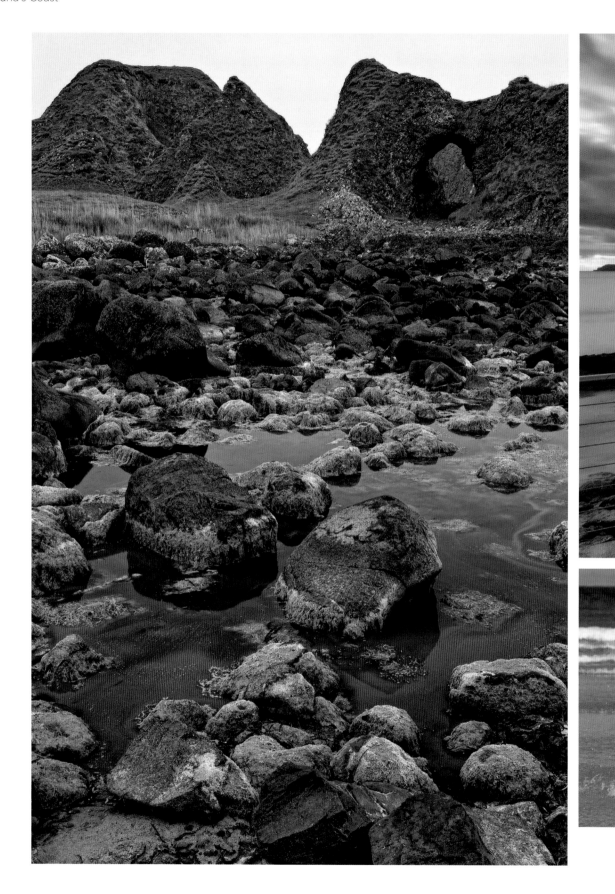

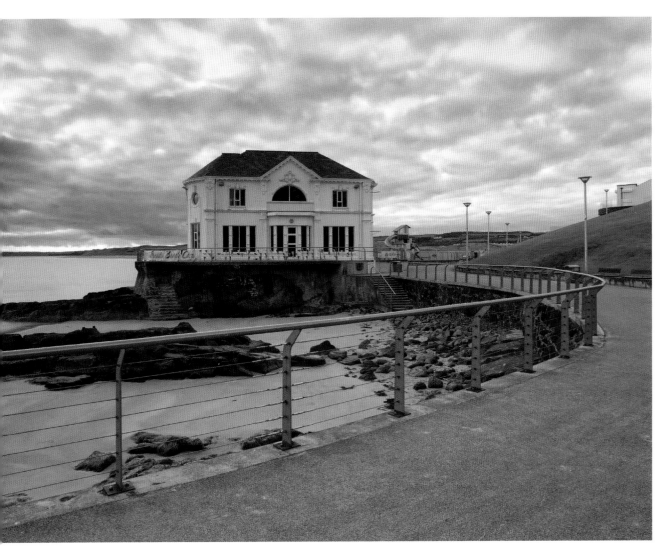

The Arcadia Café has a long and colourful history to look back on. Built on a rocky outcrop in the 1920s by a local business-man, R. E. Chalmers, it soon became a thriving seaside café. In 1953 a ballroom was added that saw many of the at the time very popular showbands and in the seventies it even attracted rock acts like The Stranglers and The Undertones. The ballroom is gone now, but the café is still open and bustling.

One of the many brochures I acquired during my travels is entitled Portrush Rocks and this title sums it up nicely for the whole of the Antrim coast.

Left page: Red tide, Ballintoy, County Antrim
Right page top: Arcadia Café, Portrush, County Antrim
Right page bottom left: Beach fun, Portrush, County Antrim

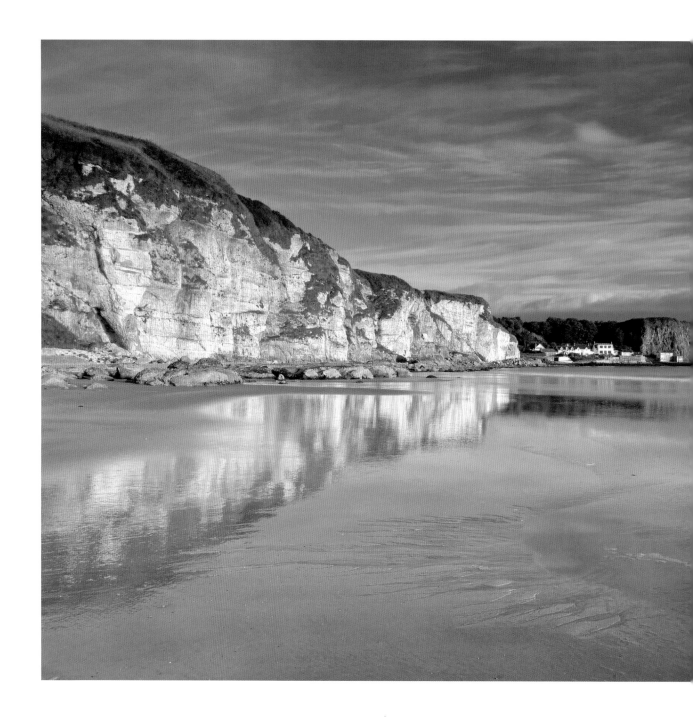

Left page: Whitepark Bay and Portbradden, County Antrim
Right page: Sandstone, Murlough Bay, County Antrim

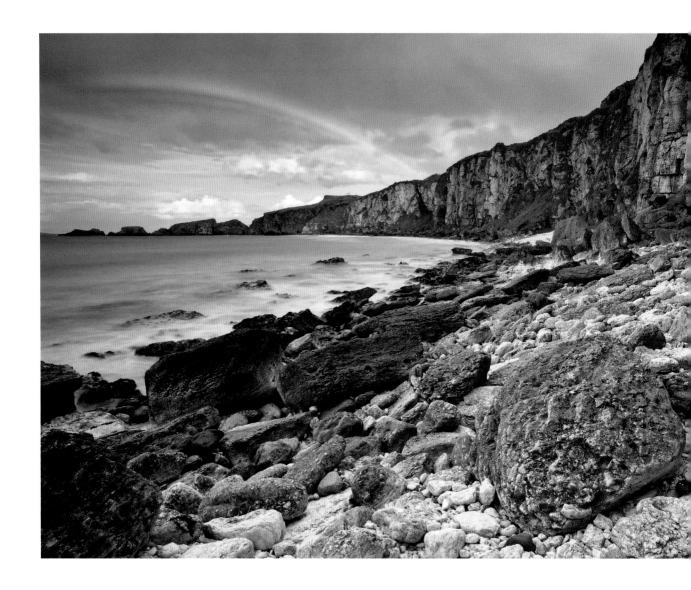

Even to the visitor who couldn't care less about geology and rocks it becomes apparent that something extraordinary must have happened here. Dark black stones lie side by side with pure white ones and in some places dark red and brown rocks join the party.

The oldest rocks in the area are clays and schists which were formed around 190 million years ago. During the Cretaceous Age, which ended around 65 million years ago, sandstones and limestones, including chalk were laid down on top of the older rocks. The soft chalk deposits have disappeared from most of Ireland, but have survived in Antrim due to being covered and protected by lava. Several major lava flows between 62 and 56 million years ago covered Antrim with a thick layer of basalt. This basalt was partly worn away by the glaciers of the ice age while continuous volcanic eruptions intruded into the older rocks forming what is known as volcanic plugs.

Faulting, shifts in the relative level of the land caused by earthquakes, did the rest and brought older rocks to the same level as new rock formations. The result is a colourful and utterly fascinating rock garden.

Left page: Larry Bane Bay, County Antrim
Right page: Tree and Fair Head, Murlough Bay, County Antrim

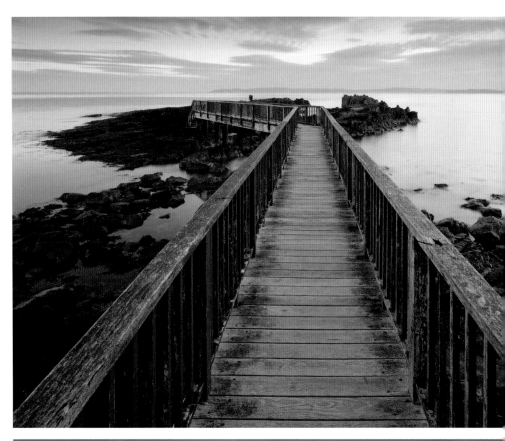

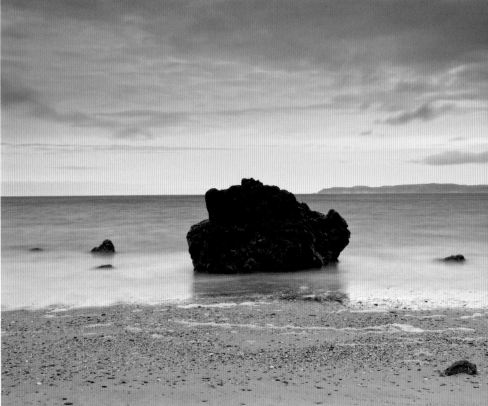

Left page top: Pans Rock, Ballycastle, County Antrim
Left page bottom: Ballycastle Beach with Rathlin Island, County Antrim
Right page top: Kinbane Castle, County Antrim
Right page bottom: Ballintoy Harbour, County Antrim

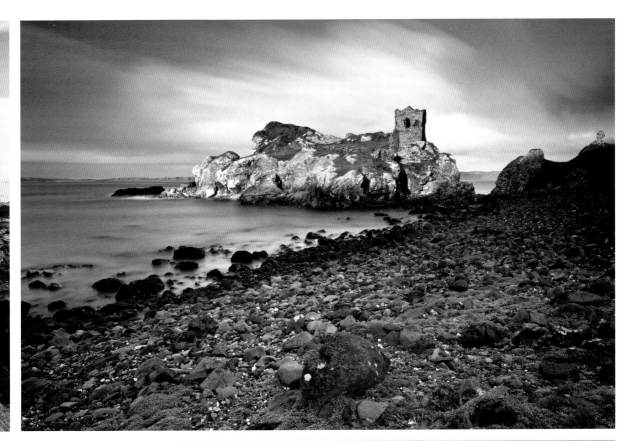

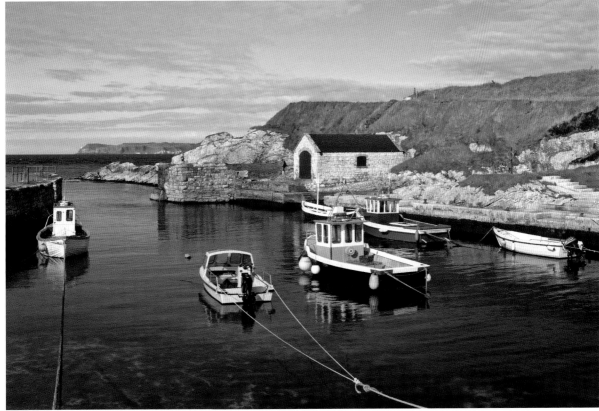

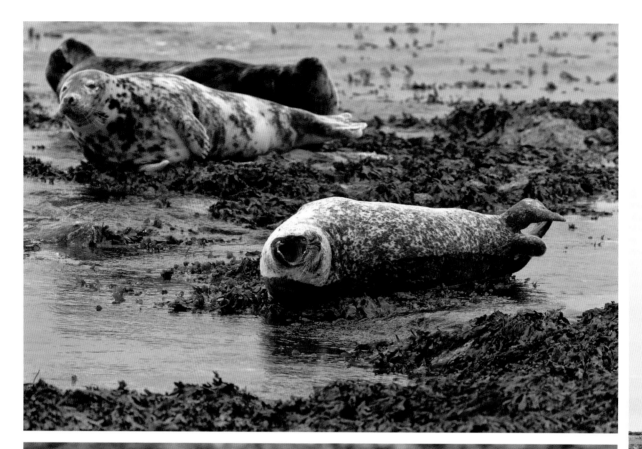

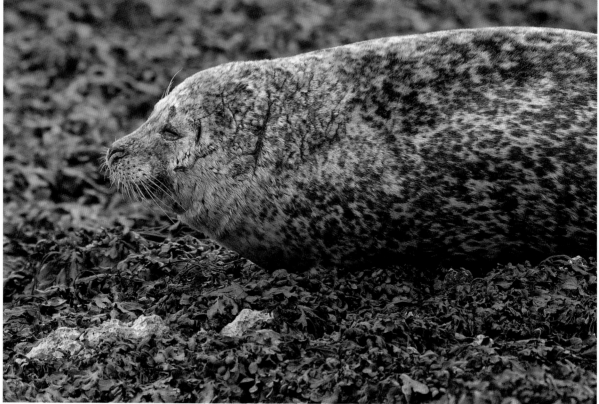

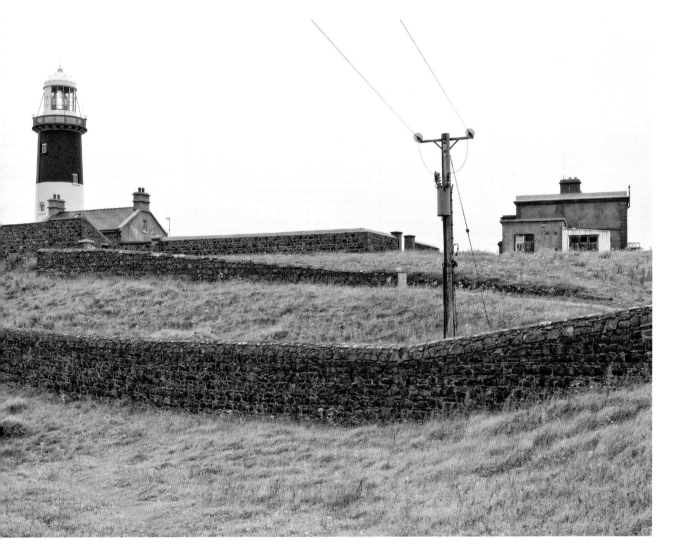

K inbane Castle is situated on a limestone headland protruding out into Rathlin Sound. Overlooking the headland and small bay are steep basalt cliffs. This is a magical and haunting location, especially when darkness approaches the shadows of the past seem to come alive.

Under the headland lies a sea cave which is known as *Lag na Sassenach*, 'the hollow of the English'; the name is believed to come from an incident in the 1500s, when a garrison of English soldiers was laying siege to the castle. The occupants of the castle lit a fire on the headland and soon help came from all directions. The English soldiers became trapped between sea and cliffs and legend has it every single one of them was slaughtered.

Left page: The lazy bunch; grey seals on Rathlin Island, County Antrim
Right page: East lighthouse, Rathlin Island, County Antrim

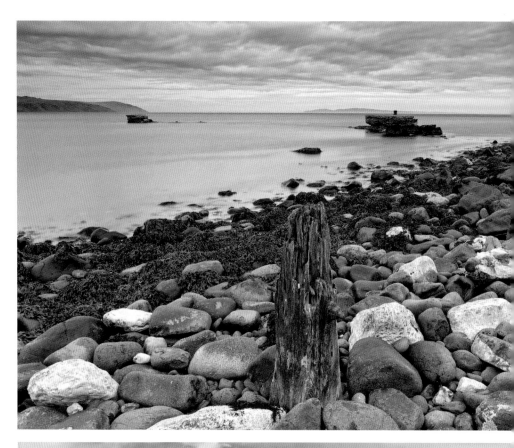

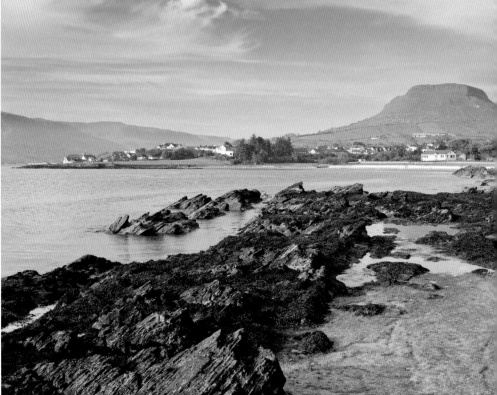

Left page top: Old Pier, Red Bay, County Antrim
Left page bottom: Cushendall and Tievebulliagh, Red Bay, County Antrim
Right page top: Yachts at Red Bay, County Antrim
Right page bottom: Belfast Docks, County Antrim

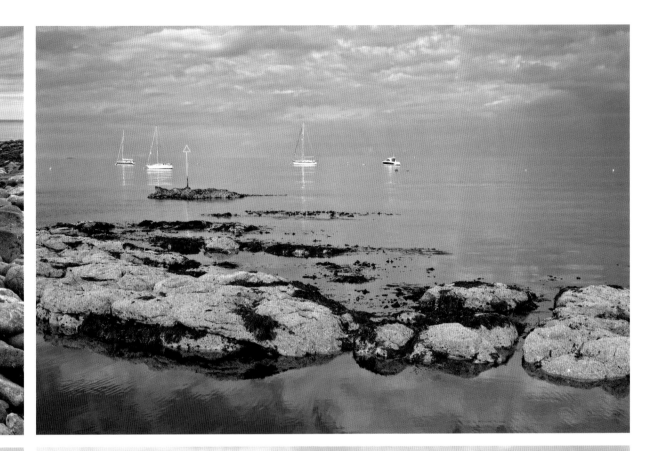

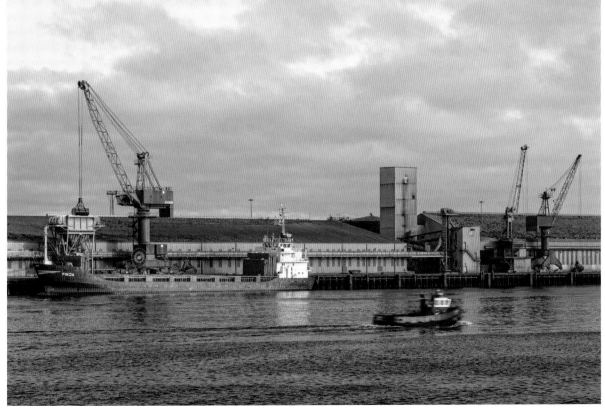

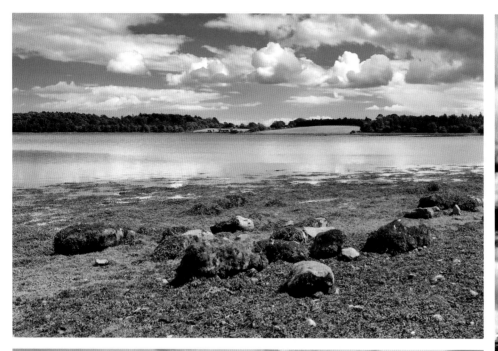

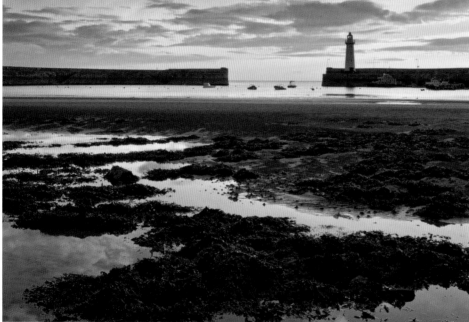

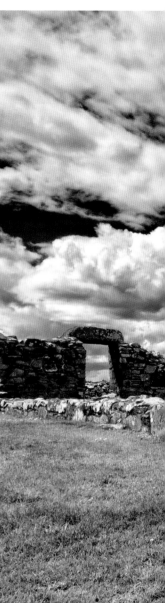

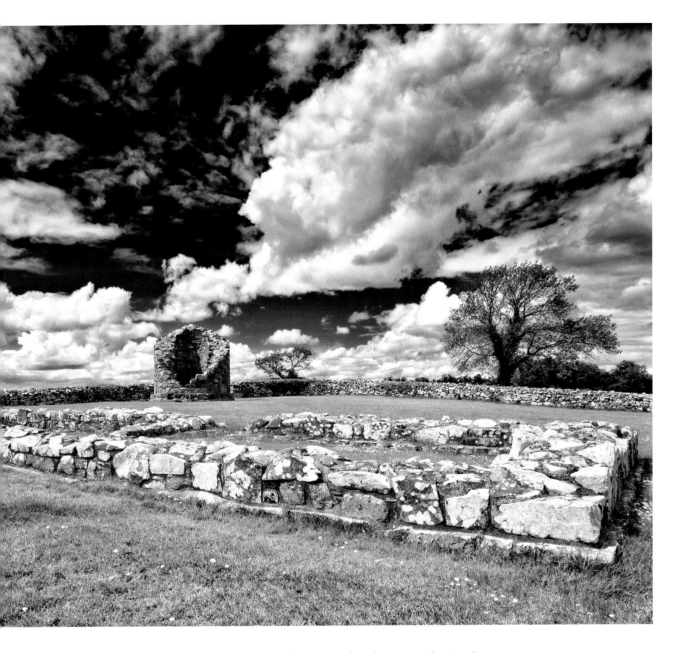

On Mahee Island, which can be reached via long and twisting roads and causeways, lies Nendrum Monastery. Although not much is left beside foundation walls this is an inspiring place and the reason why the early Christian monks choose this location soon becomes clear; the heart of the monastery, church and round tower, stand on top of a drumlin with breathtaking views in all directions. Yet it is a secluded location which I assume could be reached only by boat or a long walk across the mud at low tide back then. The origins of Nendrum are somewhat unclear but it is believed that St Machaoi founded the monastery in the fifth century and later a Benedictine cell was established which lasted from the twelfth to the fifteenth century.

Left page top: Reagh Island, Strangford Lough, County Down
Left page bottom: Donaghadee Harbour, Ards Peninsula, County Down
Right page: Nendrum Monastery, County Down

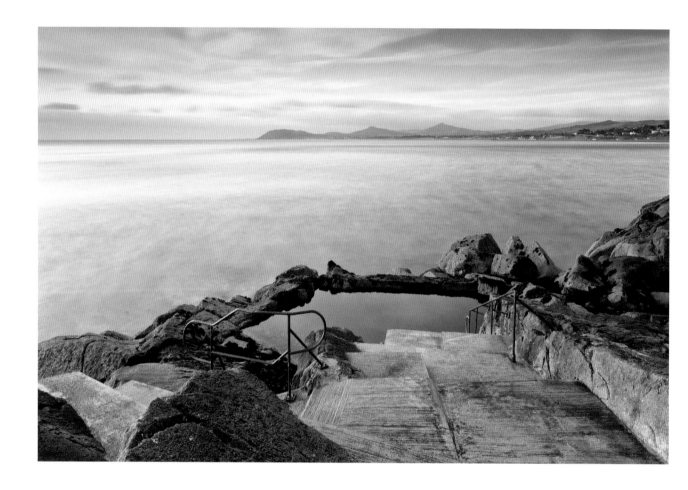

Above: Vico Baths, County Dublin

THE EAST

L Looking at a map of Ireland the eastern seaboard might appear almost boring, running in a more or less straight line from County Louth in the north to County Wicklow in the south. But although the rough drama of the west coast is missing here the shores of the Irish Sea hold other, more subtle, qualities.

Louth, also known as 'the Wee County', is probably best known for the gentle beauty of the Cooley Peninsula and Carlingford Lough with its views over to County Down where, to use the words of Percy French, 'the Mountains of Mourne sweep down to the sea'.

For me, however, the real beauty of the Louth coast lies further south. Wide sandy beaches and mudflats are only intercepted by a few rocky headlands and river estuaries. One of my favorite places on this stretch of coast is the Boyne estuary. It offers an extensive dune system and adjoining sandy beach with a rich wildlife and, as a special treat, the wreck of MV Irish Trader, a 344-tonne vessel that stranded here in 1974 when it missed the entrance to Drogheda harbour.

Further south, the Wicklow coast is visually a very similar affair with seemingly-endless stretches of pebble and sandy beaches and the occasional rocky headland.

The dominating force of the east coast, however, is without a doubt the greater Dublin area. Heavily populated and industrialised it's hard to expect anything other than concrete and traffic. Surprisingly, though, Dublin has some of the most beautiful stretches of coast in the country.

There is always the humming and buzzing of the city in the background, the rattling of the DART, and the regular beeping of a car horn or the occasional siren of an ambulance. But apart from that Malahide, Howth, Dalkey and Killiney, to name but a few places, are as beautiful and peaceful as it can get. With the Booterstown Marsh and Bull Island there are even two nature reserves right in the city.

Left to right: Sheep's Bit, Howth Head, County Dublin. Bladderwrack, Sutton/Dublin Bay, Dublin. Pyramidal Orchid, Bull Island, Dublin

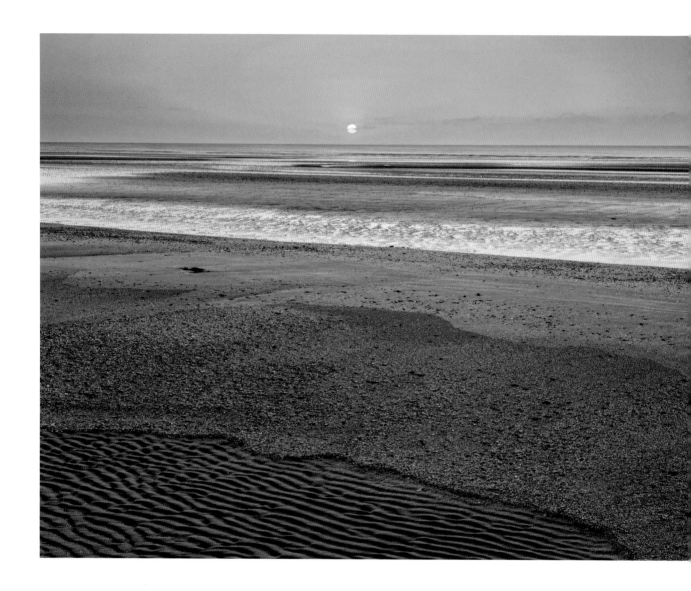

Left page: Sunrise, Port Strand, County Louth
Right page: Carlingford Lough and Mourne Mountains, Cooley Peninsula, County Louth

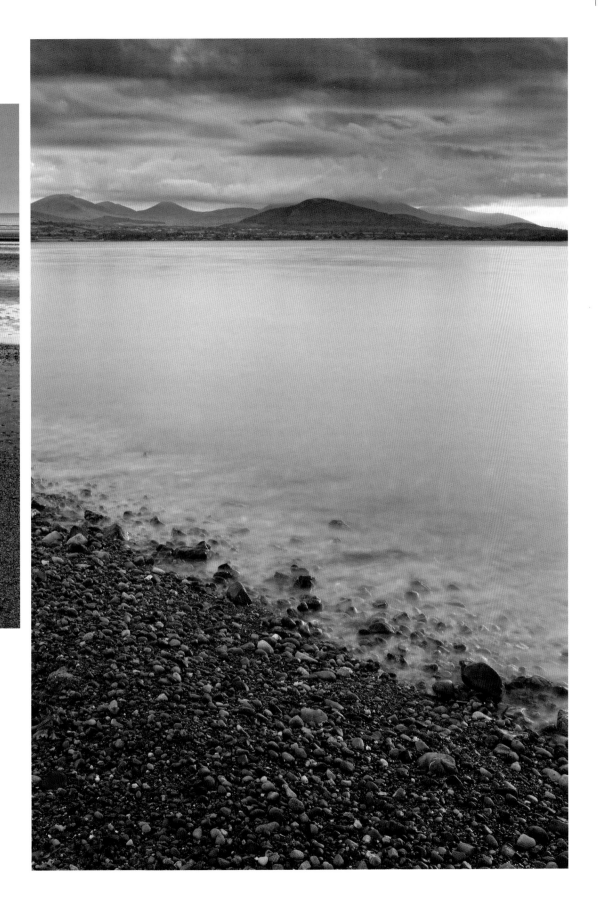

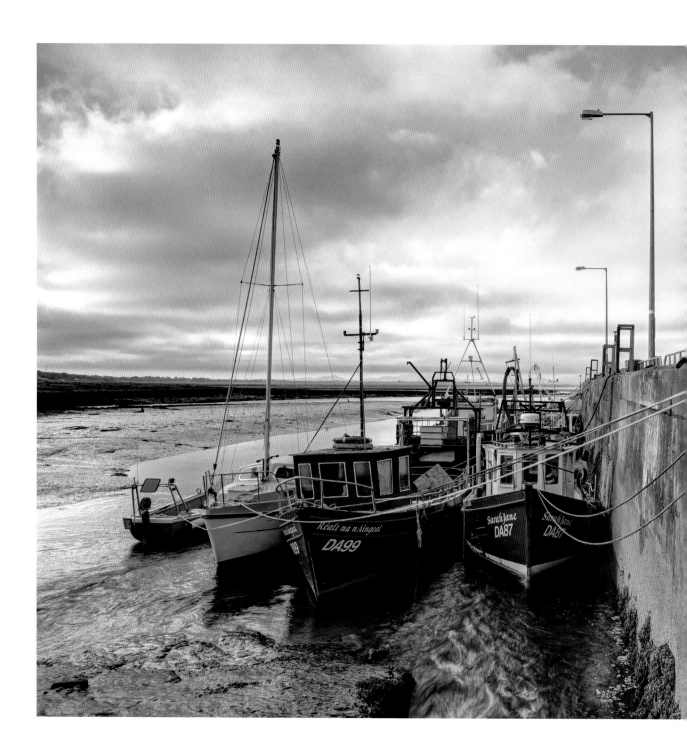

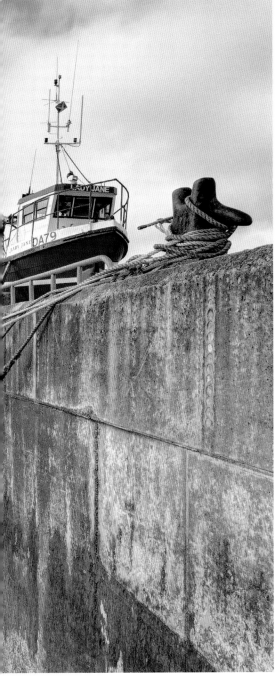

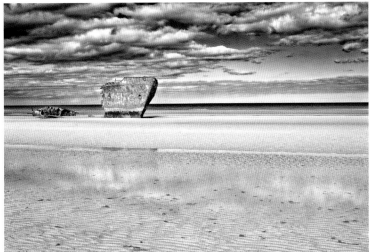

Left page: Annagassan Harbour, County Louth
Right page top: The Baltray Shipwreck, County Louth
Right page bottom: Dundalk Harbour, County Louth

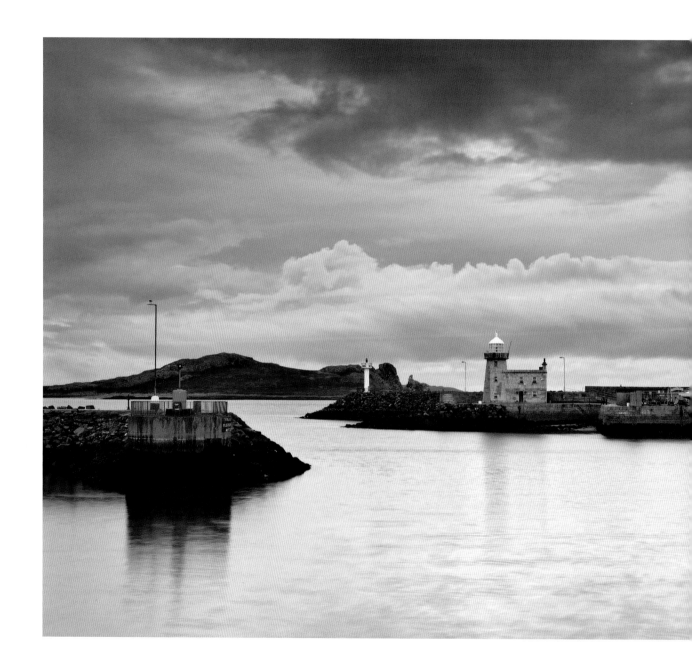

The Howth Peninsula embraces and dominates the north of Dublin Bay. Its name most likely derives from the Norse '*hoved*' meaning 'head'.

Danish Vikings invaded Howth for the first time in 819 and the descendents of these invaders with names like Hartford, Thunder or Waldron are still alive and well in Howth today.

The peninsula's main attraction is the harbour, which incorporates a busy fishing port and a marina. The harbour was first built in 1818 and was redeveloped and extended in the early 1980s.

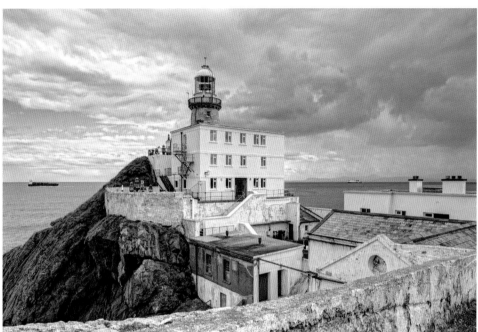

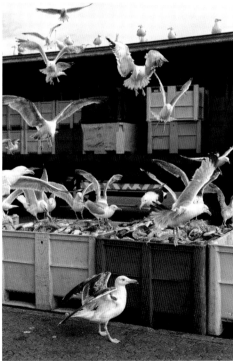

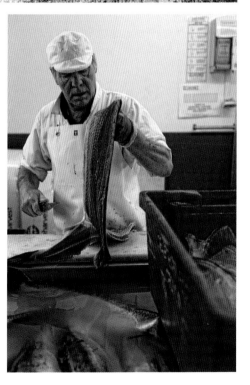

Left page: Howth Harbour with Ireland's Eye, County Dublin
Right page top: Baily Lighthouse, Howth Peninsula, County Dublin
Right page bottom left: A Hitchcock moment, gulls at the West Pier, Howth, County Dublin
Right page bottom right: Fishmongers at Doran's, Howth, County Dublin

Today the east pier is home to the marina and is very popular for a stroll down to the lighthouse where you can enjoy the view over to Ireland's Eye. The west pier hosts a range of fish shops and seals can often be seen here; I assume they're here for the fish and who can blame them. The fish and chips you can get in Howth are superb, I practically live on them every time I visit.

Howth, however, is much more than just a pretty harbour. Up the road from the east pier starts the cliff path that leads once around the peninsula. On the way lie places with such illustrative names like Fox Hole, Piper's Gut, Lion's Head and Hippy Hole. About halfway around, situated on a small promontory, stands Baily Lighthouse guarding the entrance to Dublin Bay.

Bull Island is about eight kilometres long and almost a kilometre wide and takes up the northern half of Dublin Bay. North Bull Island is a National Nature Reserve and Bird Sanctuary and holds a wide range of natural habitats like salt marsh, freshwater marsh, dunes and a sandy beach. These habitats support an astonishing variety of flora and fauna. Up to 27,000 birds, mainly waders and wildfowl, are present at any time and the dunes are home to wild flowers, including the beautiful Marsh Orchid and Pyramidal Orchid.

However North Bull Island is not a real natural wonder, it is, at least in parts, manmade. During the eighteenth and nineteenth centuries, works were carried out around Dublin Bay to prevent the silting up of the Liffey channel in the bay and to allow shipping traffic to continue. The results of these works are known as the Great South Wall (or South Bull Wall) which was the longest sea wall at the time of building, and the North Bull Wall. Sand and silt was now carried out further into the bay and deposited at what, over time, became North Bull Island.

One thing that catches the eye while strolling around North Bull are two chimneys across the bay. These chimneys belong to Poolbeg Power Station, the dominating landmark of the Dublin coast. No matter where you go north and south of Dublin Bay the chimneys are always there and are visible from as far away as Bray Head in County Wicklow. The electricity generating plant was built between 1960 and 1978 and its chimneys remain among the tallest structures in Ireland today.

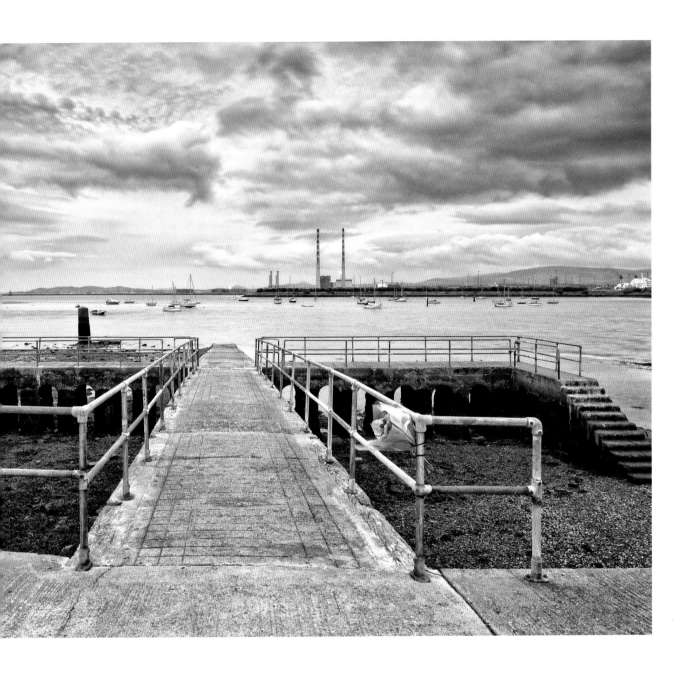

Left page left: Dunes, Bull Island, Dublin
Left page right: The Wooden Bridge, North Bull, Dublin
Right page: Docklands from Clontarf, Dublin

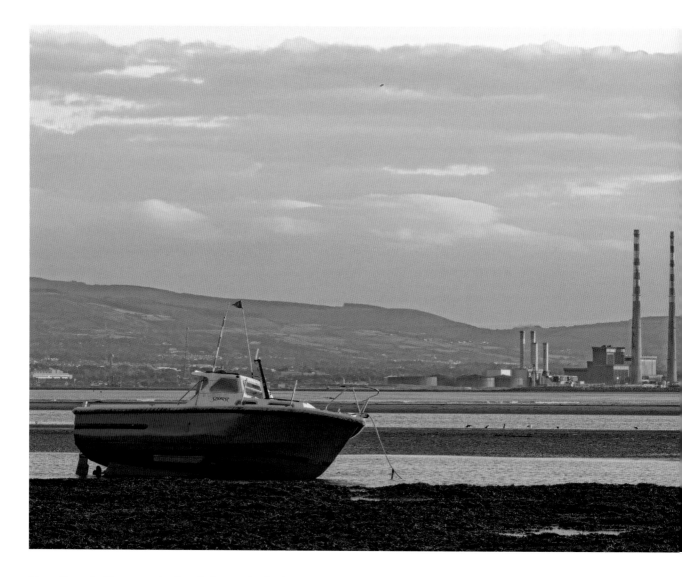

Martello Towers can be found all around Ireland's coast, but more than half of them were built around Dublin Bay, where all twenty-eight towers were in a line of sight to allow easy communication and provide a tight defense net.

The origins of the Martello Towers go back to the eighteenth century when British warships unsuccessfully attacked Mortella Point in Corsica, which was guarded by a round, thick-walled fortress equipped with several guns pointing seaward. The fortress was eventually captured eventually from land, but the British were so impressed by the concept of the building that they copied it. During the first half of the nineteenth century the British built over a hundred of these towers, fifty of them in Ireland to guard the coast against a French invasion. The invasion, however, never came.

Left page: Dublin Bay with Poolbeg Power Station, Sutton, Dublin
Right page: Saltmarsh, North Bull Island, Dublin

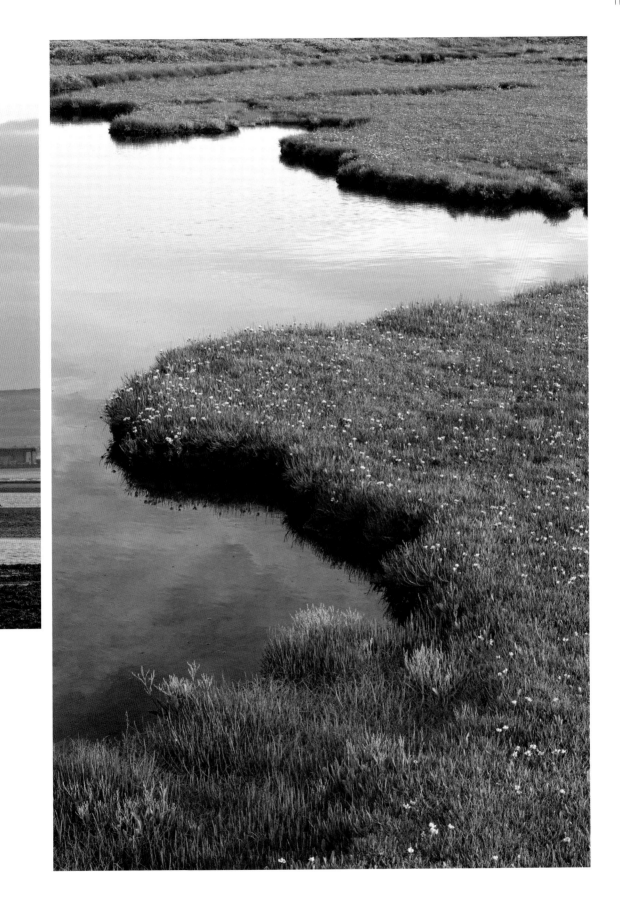

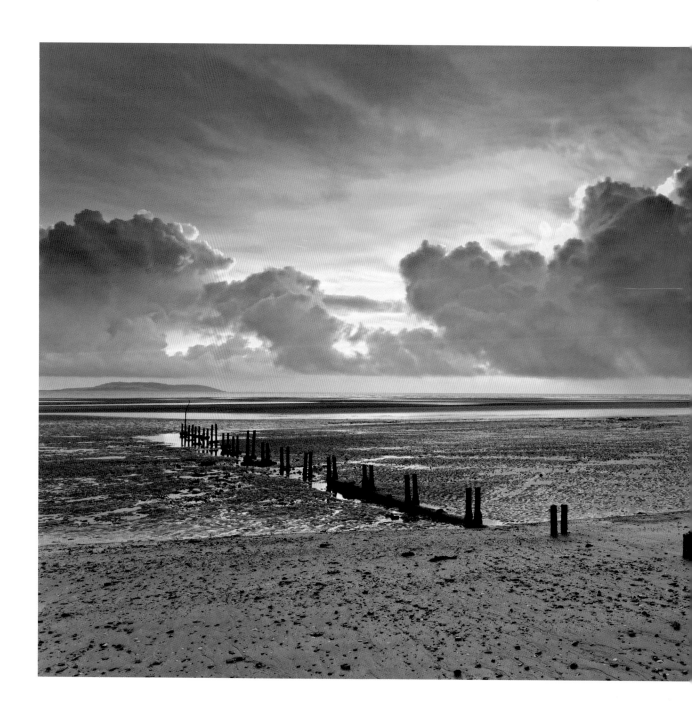

Left page: Malahide Strand, County Dublin
Right page: Malahide Seafront, County Dublin

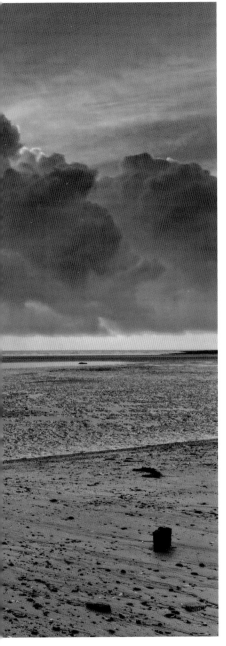

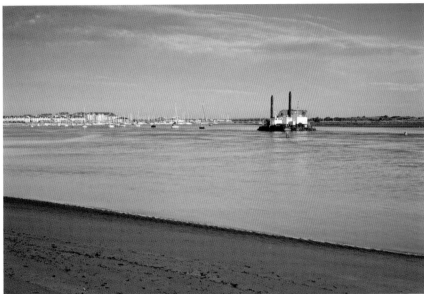

Today many towers have found alternative uses. Some are museums (The James Joyce Museum at Sandycove), some are or have been privately owned (U2's Bono lived at the Bray Martello Tower for a while) or can be rented as a holiday home (the tower at Sutton). Others have been used as a café, a sweet shop and one houses the Genealogical Society of Ireland.

Some of the places I have been really looking forward to visit in the greater Dublin area were the baths. Several gentlemen's bathing areas that have been in use for some 250 years can be found all along the coast. They were established as men-only bathing spots so Victorian gentlemen could take a dip in the nip away from prying eyes. The Forty Foot in Dun Laoghaire is probably the best known. The Vico Baths, situated at Killiney Bay, took me the better part of a day to find, its entrance only a small gap in the wall and from there down to the sea. There is something about these places, an aura of bygone days. Although women are allowed to swim there now, one can still occasionally meet a gentleman in his birthday suit. These individuals are, understandably, rather reluctant to be photographed.

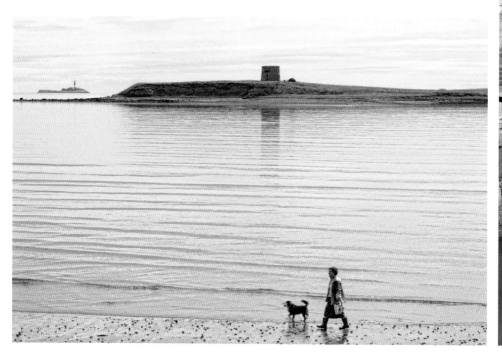

Left page: Woman, dog and Shenick's Island, Skerries, County Dublin
Right page: Coliemore Harbour and Dalkey Island, County Dublin

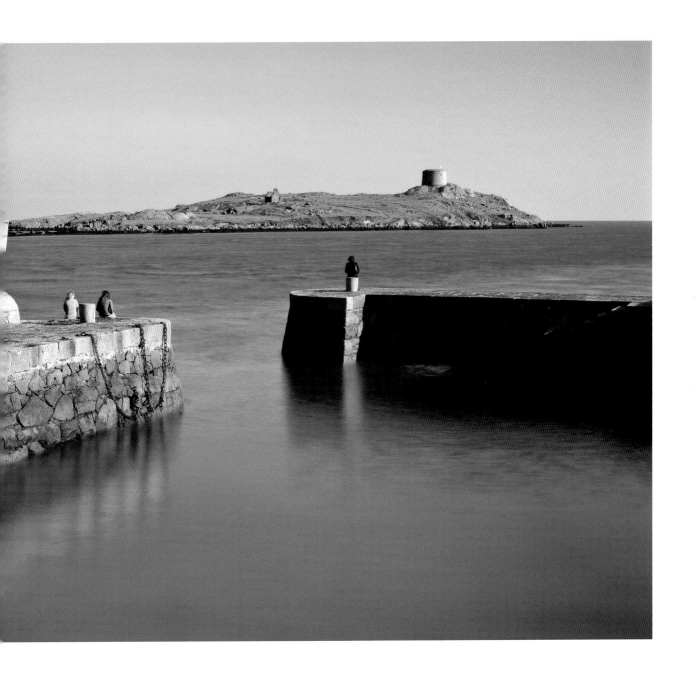

Left page top: Yachts off Killiney, County Dublin
Left page bottom: The Forty Foot, County Dublin
Right page top: Killiney Strand, County Dublin
Right page bottom: Yacht, Dalkey Island and Martello Tower, County Dublin

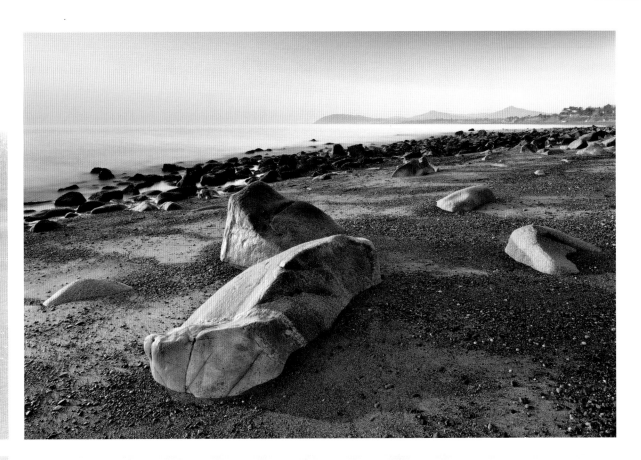

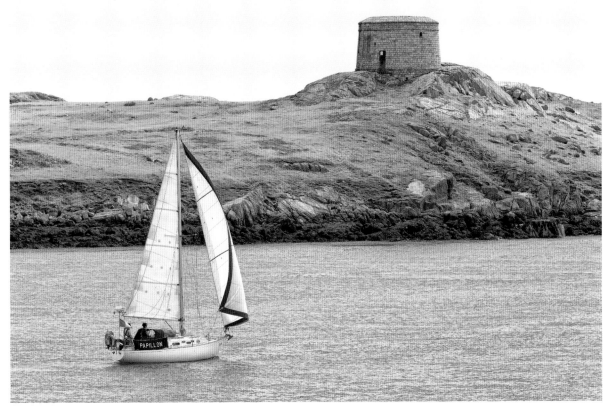

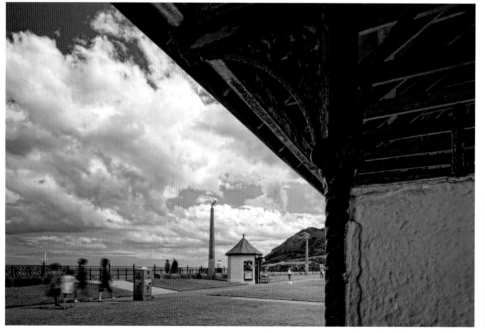

Left page: Bray Seafront, County Wicklow
Right page: Leamore Strand, County Wicklow

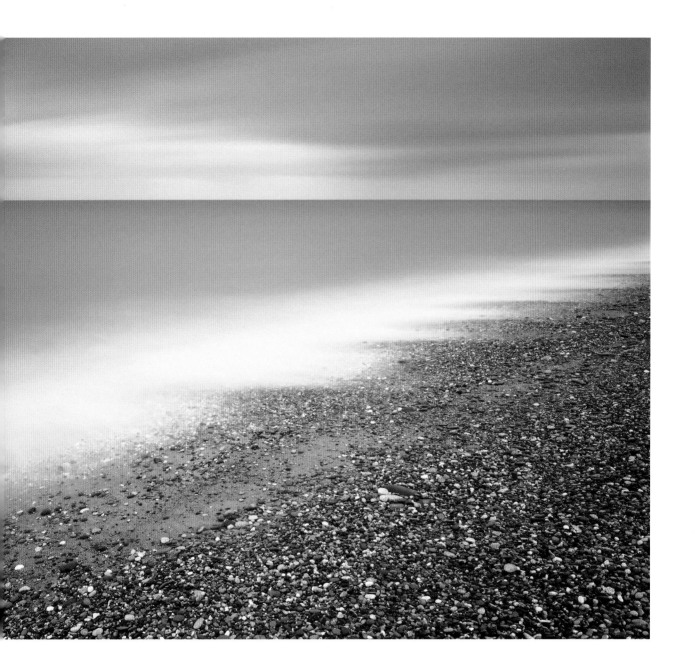

This edition first published 2016 by
The O'Brien Press Ltd,
12 Terenure Road East, Rathgar,
Dublin 6, D06 HD27, Ireland.
Tel: +353 1 4923333; Fax: +353 1 4922777
E-mail: books@obrien.ie.
Website: www.obrien.ie
The O'Brien Press is a member of Publishing Ireland.
Originally published in hardback in 2013 by The O'Brien Press
Reprinted 2019.

ISBN: 978-1-84717-822-0
Text & photography © copyright Carsten Krieger, 2016
Copyright for typesetting, layout, editing, design
© The O'Brien Press Ltd

Cover Design by Tanya M Ross www.elementinc.ie
Design and Layout by Tanya M Ross www.elementinc.ie

8 7 6 5 4 3 2
22 21 20 19

Printed in Drukarnia Skleniarz, Poland.
The paper in this book is produced using pulp from managed forests

Published in:

DUBLIN
UNESCO
City of Literature